Mother and Child

First published in 2015 by

Glitterati
INCORPORATED

New York | London

New York Office:
630 Ninth Avenue, Suite #603
New York, New York 10036
Telephone: 212 362 9119

London Office:
1 Rona Road
London NW3 2HY
Tel/Fax: +44 (0) 207 267 9479

www.GlitteratiIncorporated.com
media@GlitteratiIncorporated.com for inquiries

The scientific names in this book are from the IUCN Red List and were
supplied by the Taronga Zoo in Sydney, Australia.

First edition, 2015

Library of Congress Cataloging-in-Publication data
is available from the publisher.

Hardcover edition ISBN 13: 978-0-9903808-7-0
Design: Sarah Morgan Karp/smk-design.com

Printed and bound in China by C P Printing, Limited

10 9 8 7 6 5 4 3 2 1

Mother and Child

Wildlife Photography

Reg Grundy

PREFACE BY *Douglas Kirkland*
FOREWORD BY *Guy Cooper*
EPILOGUE BY *Joy Chambers-Grundy*

Glitterat*i*
INCORPORATED

New York | London

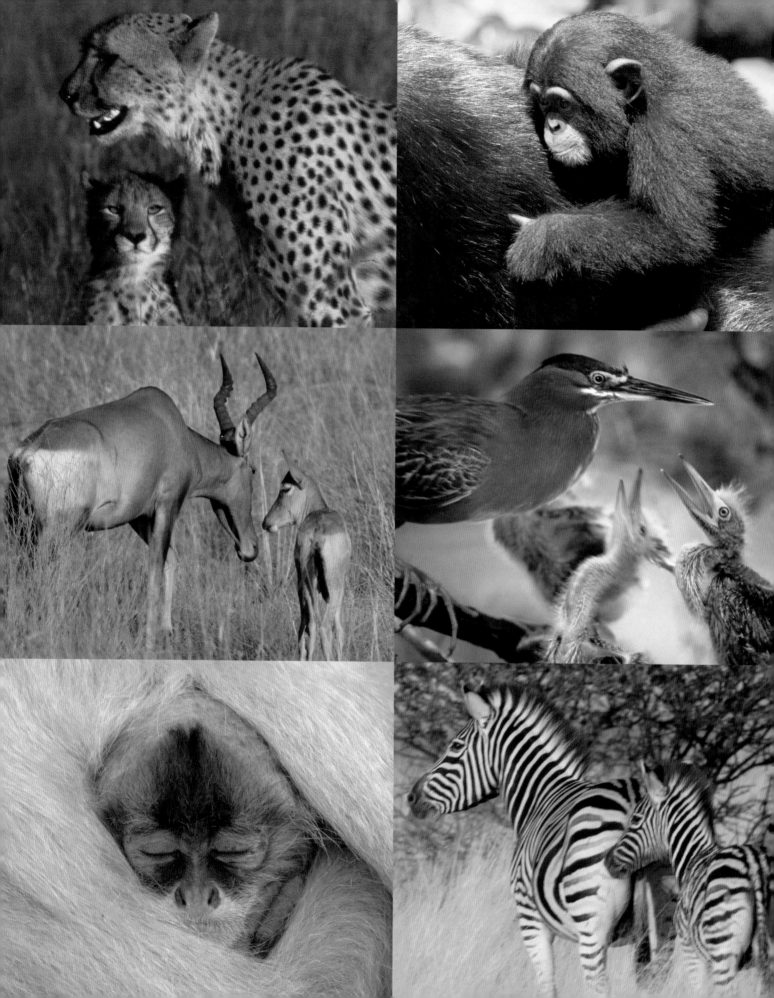

Contents

At left, from left to right: A baby cheetah *(Acinonyx jubatus)* stares at the camera while its mother, the fastest land animal on earth, regards the veldt; a baby chimpanzee *(Pan troglodytes)* rides on its mother's back, an easy way to travel through Africa; a mother hartebeest *(Alcelaphus buselaphus)* and its calf wander calmly through the long grass of the NW Province, South Africa; a green-backed heron *(Butorides striata)* feeding its demanding young in the swamps of Florida, USA; a baby spider monkey *(Ateles sp.)* sleeps peacefully under its mother's arm—forest dwellers from Mexico south to Brazil; a zebra *(Equus quagga)* and foal in the dry winter of Kruger National Park, South Africa.

Following page: This quite remarkable specimen of a lion-tailed macaque *(Macaca silenus)* nurses its baby in the morning sun, while the little one clutches its mother with a "hand-like" foot.

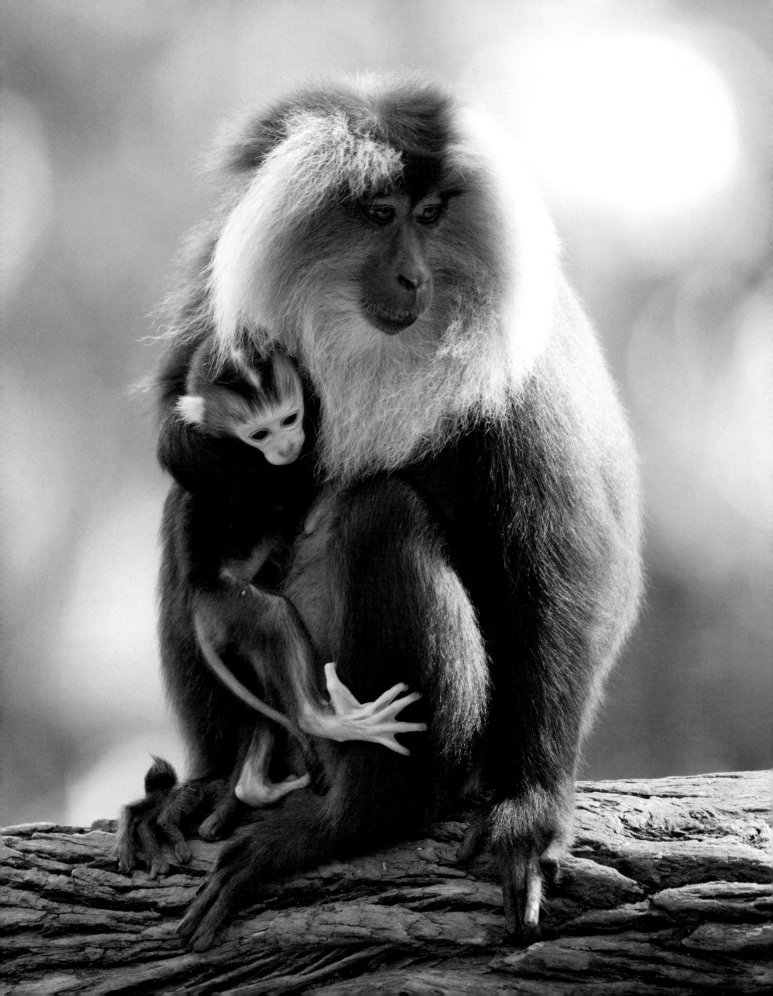

Preface

My good friend Reg Grundy is an extremely modest man who has typically avoided everything associated with publicity even though he has achieved world fame. I discovered his amazing capabilities as a photographer quite by accident, when many years ago I met Reg and convinced him to bring some of his slide images to me. Then later, walking with him through a dimly lit hallway leading to his personal study, I encountered a dozen or so of his animal photographic prints hanging on the wall. When I expressed my amazement at the quality of what I was looking at, he seemed surprised and told me he had only entered these images in a few photo contests, with modest results.

Within a day or two, I found myself sitting with him at his computer, putting some of these pictures into imaginary book layouts to show him the true value I recognized in his work; I wanted him to publish his powerful photographs for the world to appreciate. This ultimately led to his first photographic book, *The Wildlife of Reg Grundy,* which was received with great acclaim.

At this point his enthusiasm and passion increased, leading to another evolution in Reg's creative and imaginative process—that of observing animal life as families raising their young, especially the intimacy between mother and child. Many of these unique and magnetic images appear in this book.

I consider myself very fortunate indeed to have shared my love of photography with such a remarkable man as Reg Grundy—and Françoise and I are proud to call Reg and his beautiful, talented wife, Joy, our close friends and companion artists.

— Douglas Kirkland
Hollywood

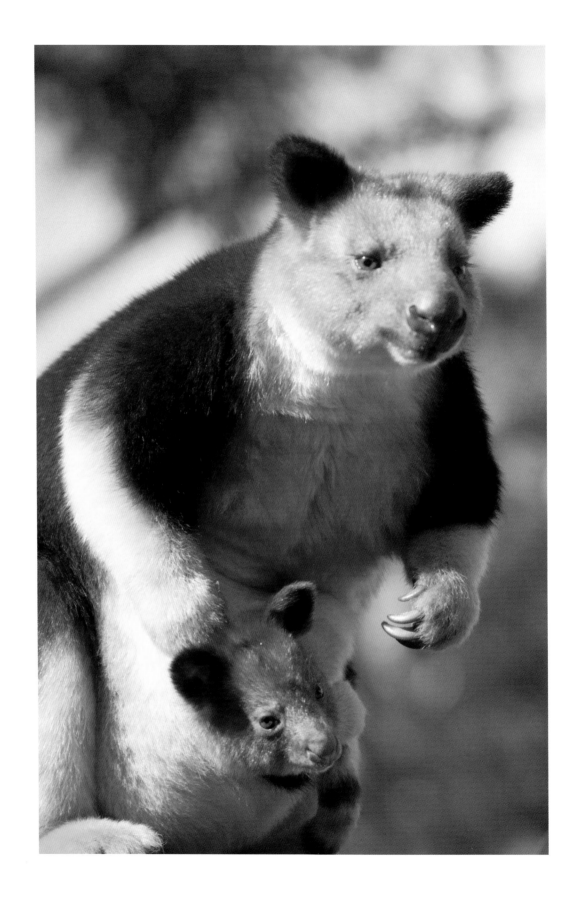

Foreword

The ingrained and protective instinct held by a mother for its young is a driving force and fundamental factor of life itself. That deep-seated and nurturing relationship is both palpable and universal but complex to capture, even for the most skilled and patient photographer. It has been my good fortune to gain some understanding of the painstaking journey undertaken in capturing the essence of that unique relationship so beautifully revealed within these pages.

With its breathtaking harbor-side setting, natural habitat, and wide ranging native and exotic animal collection, Sydney's Taronga Zoo is a fabled drawcard for visitors to our shores. In my time as Director, Taronga and its sister institution, Western Plains Zoo, were privileged to host renowned global figures including Nelson Mandela, David Attenborough, and Kofi Annan, plus a coterie of crowned heads and giants of the entertainment world.

In a similar vein, on a well-remembered day in 2005, my usually unflappable assistant came rather breathlessly with the message, "It's Reg Grundy on the phone!" Endeavoring to exude an everyday persona, I quickly took the call from this legendry and inherently very private Australian, who is listed as one of our nation's most influential figures ever, a giant of the global television industry and, as such, recognized as one of the world's foremost creative and business talents—a man upon whom countless accolades have been justifiably bestowed.

But the catalyst for this rather unanticipated phone call stemmed from the launch earlier that year of *The Wildlife of Reg Grundy*, an inspiring photographic record and very personal tribute to the wildlife of this world and an accomplishment reflecting one man's passionate love and advocacy for nature.

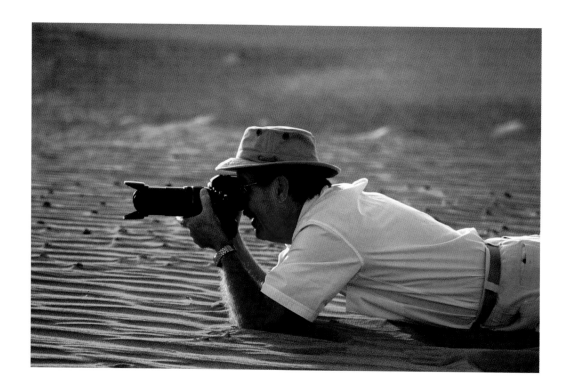

Above: Reg shooting in the Arabian Desert; *Previous page:* A tree-kangaroo *(Dendrolagus goodfellowi)* with a joey in its pouch, enjoying the sun in Australia. These small kangaroos have adapted to life in the trees. Unlike their ground-dwelling cousins, tree-kangaroos can walk backwards, an essential skill when crossing through branches. The Goodfellow's Tree-kangaroo *(Dendrolagus goodfellowi)* is classified as an endangered species, and their numbers in the wild are decreasing.

A copy of *The Wildlife of Reg Grundy* is nearby as I write. Like all much-loved books, it bears the warm patina of frequent page turning, enthusiastic finger pointing, and the friendly impacts wrought by visiting grandchildren ever captivated by its memorable and striking images.

Deeply impressed that someone with the amount of calls upon his time would undertake such a production, revealing a record of his encounters with wildlife, I had written to RG (as I am privileged to now call him) with an invitation to visit Taronga. While I confess to that initial but delighted surprise at receiving a phone call in reply that day, having now come to know and enormously admire his innate humility and sincerity and his abiding love and reverence for wildlife, I recognise that that surprise was clearly misplaced.

Foremost among topics that evolved throughout the many discussions we were to share was his deeply held appreciation of the significance of the unique, almost mystical relationship prevailing between a mother and its offspring. It was now his goal to capture through his lens the essence of this critical and protective bond. That illustration of the protective and nurturing relationship between mother and child has been gently but purposefully captured and revealed in this book, page by page, frame by frame, and image by image. The pictures are both stirring and reassuring, for they talk to a behavior and relationship that is perhaps the only constant amidst the growing uncertainty faced by the wildlife of our planet.

This book and its images, however, speak not only of wildlife and the unique role and special rapport of the mother with its child; it also reflects the man behind the camera, his inordinate patience and resourcefulness, his perception and understanding, his sensitivity and values, and, yes, even his mischievous smile. For, undoubtedly, capturing a view of nature on this scale and dimension—one embracing a unique and diverse range of wildlife from both hemispheres' mountains and high veldt, woodlands and rainforest, and jungles and oceans—is as much an experience as a demanding adventure. It would take someone with Reg Grundy's insight and perception to conjure this theme, just as it would take someone of his unerring skill with the camera to capture these ever-elusive moments, portraying the dynamic and life-giving connection between mother and child.

It has been my fortunate privilege to know and to share a common interest with a most unique man who has generously deployed his wide-ranging talents on behalf of the world's wildlife. I am certain your journey through these reflective pages, with their captured moments of precious interplay and their sensitive portrayal of mother and child, will be as illuminating and inspirational as it has for me.

— Guy Cooper
Mosman, Sydney

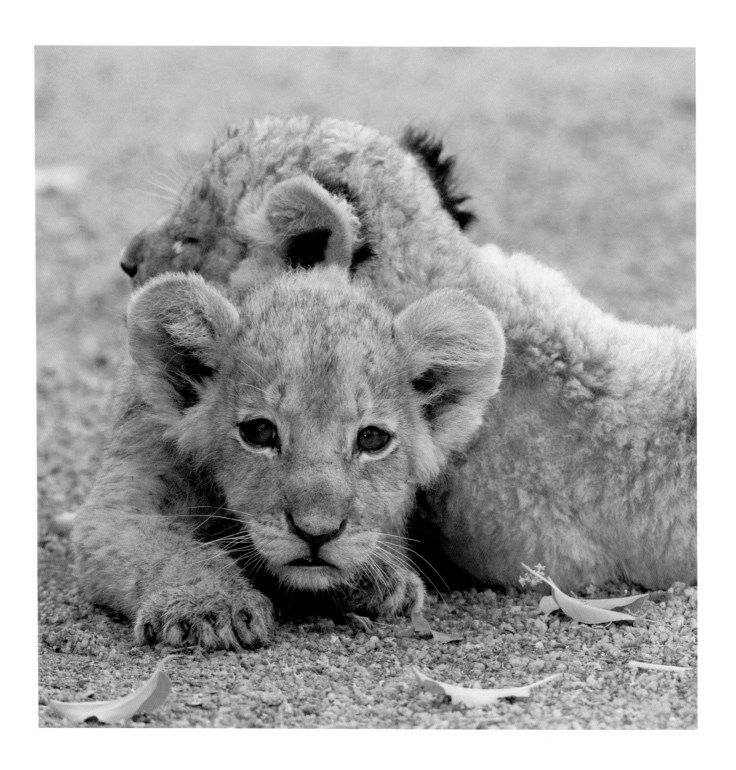

Introduction

Photographing animals is my delight. There is little doubt that I am happiest out in the wild with my wife at my side and a camera in my hand. I have spent my entire life in pictures and sound, bringing images to viewers one way or another, beginning as a young man in Australia on radio, mainly calling boxing matches and rugby league football; then for four decades as a producer, making television programs around the world; and now, my final tribute—as a recorder of the creatures of the wild. This book is a dedication to the resilient animal mothers of this planet and their amazing offspring.

In my autobiography I tell of my first meeting with Douglas Kirkland, one of the world's stellar and most celebrated photographers, my photographic mentor and dear friend. It was over 20 years ago in Los Angeles that he was taking pictures of my wife, Joy Chambers, for a story in an Australian magazine after the publication of her second book, *My Zulu, Myself.* I had always been interested in photography, had always owned a camera, and had always been drawn to photographing animals.

That day Joy proudly told Douglas of my interest in photography, and that I was a "great" wildlife photographer. It was towards the end of that session that Douglas turned to me and said, "Why don't you drop by our house and bring some of your slides? I'd like to see them."

I could see he meant what he was saying. However, I am not someone who seizes upon invitations like that. I procrastinated for many months, yet Douglas's suggestion remained with me. Finally I made contact and went to visit him in his house in the Hollywood Hills. I carried my bundle of slides along and tentatively began to show them to him.

When Douglas told me that he agreed with my wife's opinion, I found it hard to reply. I was amazed and delighted. Such an accolade coming from the already proven "great" photographer Douglas Kirkland gave me the self-belief I needed to persevere. Yet it was not until 1995, when we sold our television production company, Grundy Worldwide, that I at last found enough time to devote to my avocation, which has become my passion. Since then I have visited every continent, pursuing this consuming need I have for getting the right shot.

The "right shot" is often hard to find. I have searched for it in the icy climes of lonely beaches down gloomy, steep cliffs near Dunedin in the South Island of New Zealand, where the beautiful, endangered, yellow-eyed penguin lives and breeds on the shore. In contrast I have stood in the constant blanket of heat and dust in Ranthambore, India, where we sought and recorded the reclusive tiger.

As every wildlife photographer knows, you have to cover tens of thousands of miles to find these amazing creatures in their natural habitats. I feel blessed to have been fortunate enough to be able to do this.

We've been soaked to the skin in the mother of all storms in the Kalahari Desert with lightning striking nearby, seeking the right shots of a lioness and her cub. Alternatively we've been freezing on a snow buggy on the shores of Hudson Bay in Canada, waiting for the mother polar bear to appear with her offspring and cross the wide lake of ice in front of us. I always like to keep my fingers free to click the shutter, so I cut the tops from the index and center fingers of my gloves. This can be a bad idea when the outside temperature is 25 degrees below.

There is a wonderful exhilaration in suddenly coming upon grizzly bears or black bears wading towards you in the sparkling streams of Alaska, or waking up on the South African veldt before sunrise to leap into a four-wheel-drive vehicle and slide in behind an 800-millimeter lens. To trundle along as dawn breaks above the wide green expanse: there is the high excitement inside as the

search begins. We ask ourselves, *What will we find out here today?* In the foliage roam the animals in their natural world. I am here to capture a moment when a creature will do something special, and I will record that finite second and share it.

Many days have passed in that way. As night begins to fall, it is humbling to hear the awesome, continuous roar of a male lion: a mighty sound at dusk that holds you spellbound; the call that represents nature at its most raw. When we return to camp through trees dripping with gray monkeys, we view on our computers the photographs from the day's work. We study the pictures with a sense of accomplishment—or disappointment, depending on what we find. Tomorrow the pursuit of the "right shot" will continue.

However, being on safari is not always just intensity. There are the lighter moments. We were in Botswana a few years ago and had just been introduced to the ranger who would be our escort for the following week. He began to tell us about the animals we could expect to see in that part of the country. He added, "And of course there are all sorts of bears, as you know." We looked at him in amazement, and Joy queried, *"Bears?"*

He nodded. "Oh yes, and they come in all sizes, from little tiny ones to big, big ones."

"Bears?" my camera assistant, Grahame, inquired again, and we all looked at one another in complete confusion.

The ranger eyed us very oddly and went on, "But you have been here before, you have seen the bears. There's a big one now," and he pointed to a kori bustard *(Ardeotis kori)*, the heaviest flying bird, walking in the distance. We swiftly explained that with his accent we had thought he was saying "bears" when he was actually saying "birds." We all burst out laughing together.

This book is the culmination of many years of work. I had harbored the idea of a series of animal mother and child pictures for a long time. It became more of a focus after my first book, *The*

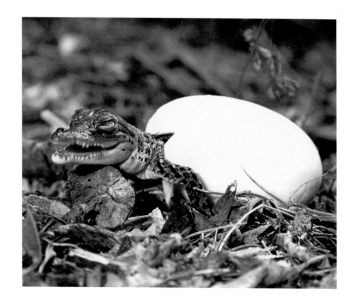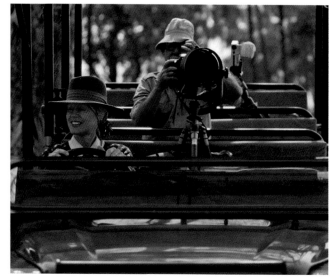

Above left: A saltwater crocodile *(Crocodylus sp.)* emerges from its egg on the banks of the Adelaide River in the Northern Territory of Australia. I took this, lying on the ground inches away, with a Canon 65mm macro lens. *Above right:* Joy drives Reg through Kruger park, South Africa, on a photographic expedition. *Page 12:* Brother and sister lion cubs *(Panthera leo)* rest together after hectic play in the dirt of the North West Province, South Africa. *Following page:* A young orangutan *(Pongo sp.)* with soulful eyes studies the camera while clinging to its mother in human fashion.

Wildlife of Reg Grundy, was published. I believe the thought first came to me on a raft in the Chobe River in Botswana, while I was photographing elephants drinking. I was impressed by the way the mature animals made room for the young to drink, and the obvious attention the mother elephants gave to their children. One of the baby elephants was possibly only days old. Its trunk behaved more like a rubber hose; it appeared to have no control over it. The mother helped the baby to drink, and the filial consideration and love I witnessed was so impressive. The protective instinct that a mother has for its child is timeless—whether it is a human mother or an animal mother. The relationship is unique. That moment was the start of this book of photographs. My gratitude goes to my publisher for giving me that chance to reveal my mother and child images.

When people view my pictures, the one question I get asked more than any other is, "How close were you?" The answer, as every wildlife photographer knows, is, "Occasionally too close."

Although with a lens like the Canon 600, along with a doubler, you don't have to be near the animal to take a vivid close-up. The reality of shooting in the wild is that it is often the animal that controls the distance between you and it. A saltwater crocodile appearing out of nowhere and leaping six feet above the Adelaide River right next to your boat in the Northern Territory of Australia can be a little disconcerting, but one nonetheless makes a swift effort to rally, swing towards it, and attempt to get a shot.

When I first photographed meerkats (Suricata suricatta) in the Kalahari Desert, I was blessed by the fact that the family we chose to record allowed us to venture right up and mingle with them. I believe this is extremely rare. We had arrived at the spot where their burrows were, before sun-up, and sat about 50 yards from them in the chill of the darkness. As dawn broke and the light broadened over the African desert, the tiny forms began to appear out of their holes in the ground and spread away from their home to look for food, comprising any of a number of small desert creatures, including scorpions.

Meerkats stand with their backs to the sun to warm themselves, and one invariably takes a look-out position on a high point— usually a dead tree or a rock. The others sun themselves or forage for food. From the many television programs featuring these desert oddities, a wide audience now recognizes the staccato movements of their heads as they look to right and left, peering far into the distance for a sign of the approach of their natural enemy, the raptor. Their vision is so keen that they can discern the birds up to two miles away in the sky. They do not forage very far from their burrows, for if "the sentry" gives a signal of danger, meaning the approach of a raptor, they scoot at high speed back into their holes for safety.

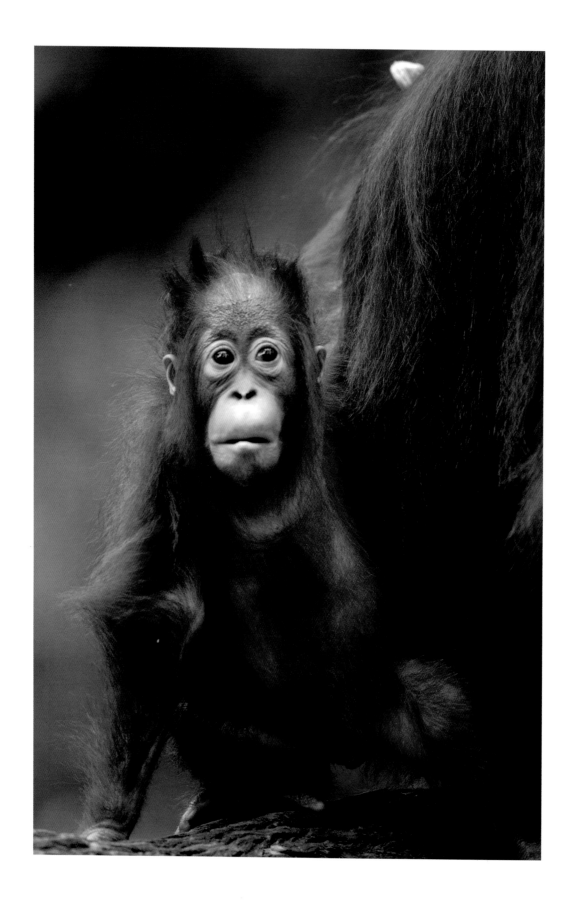

Of course this mob of meerkats knew we were there from the moment they came out into the light. Gradually, very gradually—taking over half an hour—we moved across the space between us and came closer to them as they searched for food, until we were finally actually in their midst. It was sensational, the photo shoot of a lifetime. At one point, I was lying on the ground, clicking away, when a couple scampered up to me and walked on my legs and sat upon my back (Joy was busy recording all this on video). This was one of the most fulfilling experiences of my life, to be *up close and personal* with that meerkat family.

The other question I get asked regularly is, *Which is your favorite animal?* I guess I don't have one. They are all magnificent in their own way, each unique, and many of them have given me endless hours of pleasure. I do have a favorite bird, however: the glorious longtail of Bermuda *(Phaethon lepturus catesbyi),* which I have been photographing consistently for 30 years. It is a magical miracle of flight, sweeping majestically in the sky with its pristine white body and its long tail of black and white feathers gliding behind. They nest in the cliffs on our property and we even name the hatchlings. Joy says that if I come back to earth I'll be a longtail. I wouldn't mind that a bit.

I do hope you enjoy this book, which has been an honor and a labor of love for me. I like to think that my work is big and bold, capturing the essence of the animals—their spirit. I hope the photographs in this book live up to my belief.

— Reg Grundy
Bermuda

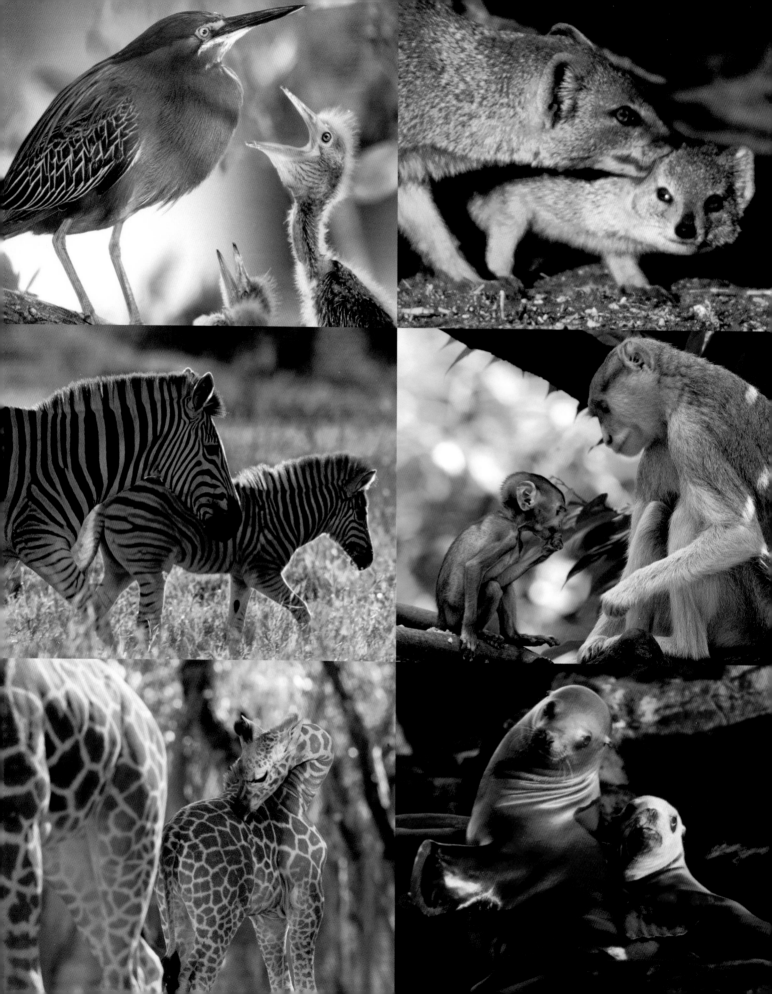

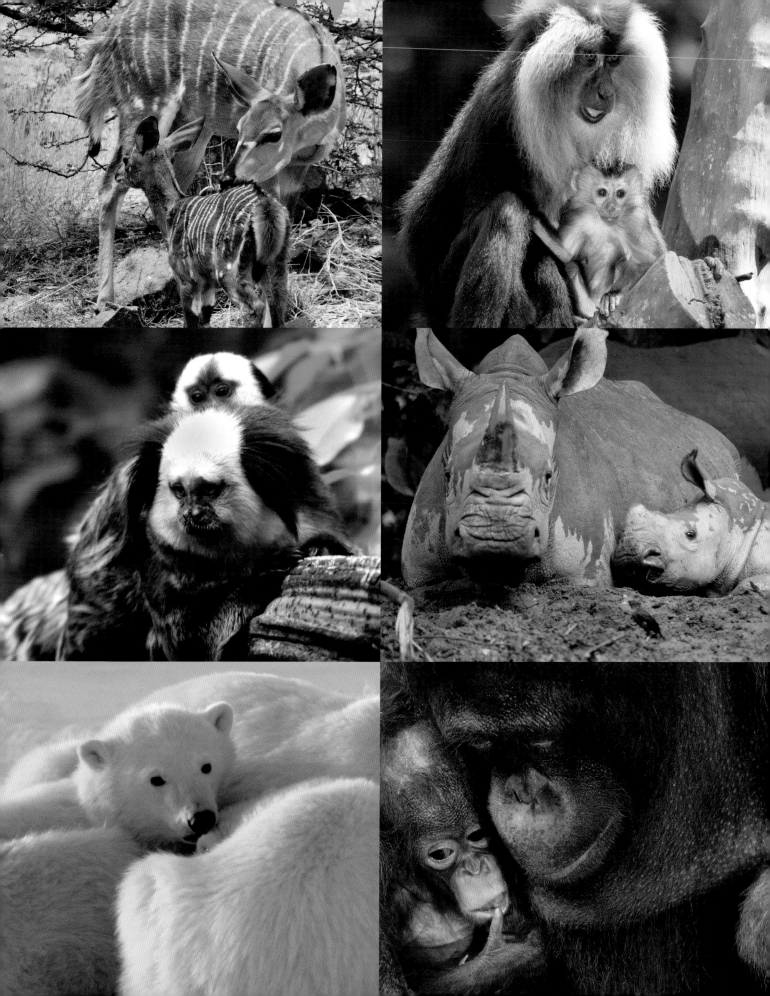

Previous spread, left to right: A green-backed heron *(Butorides striata)* with spring chicks in the wilds of Florida, USA; in the Kalahari Desert night a mother mongoose *(Herpestes sp.)* cleans its baby's ear; a mother nyala *(Tragelaphus angasii)* tends its offspring in the African savannah; a lion-tailed macaque *(Macaca silenus)* and its alert baby in an affectionate pose; a zebra mother and foal *(Equus quagga)* cross to the water in the Madikwe game reserve, South Africa; a patas monkey *(Erythrocebus patas)* watches attentively as its baby cleans itself; Geoffroy's marmoset *(Callithrix geoffroyi)* carrying a baby on its back in habitual fashion; A white rhinoceros *(Ceratotherium simum)* and her calf snuggle in the dust of Kruger Park, South Africa; a baby giraffe *(Giraffa Camelopardalis)* attends to an itch in Kruger National Park, South Africa; a sea lion and cub *(Zalophus sp.)* in the golden light of the Gulf of California, Mexico; a baby polar bear *(Ursus maritimus)* lifts its head from its siblings in the pale Arctic sun, Canada; a mother orangutan *(Pongo sp.)* cuddles its leaf-eating baby.

At right: In Kruger National Park, South Africa, near the Mozambique border, a baby impala *(Aepyceros melampus)* watches my camera while its mother's attention is elsewhere, and a red-billed oxpecker *(Buphagus erythrorhynchus)* sits on the far side of her back. Impalas are renowned for their ability to jump up to 10 feet high, and occasionally to 33 feet long.

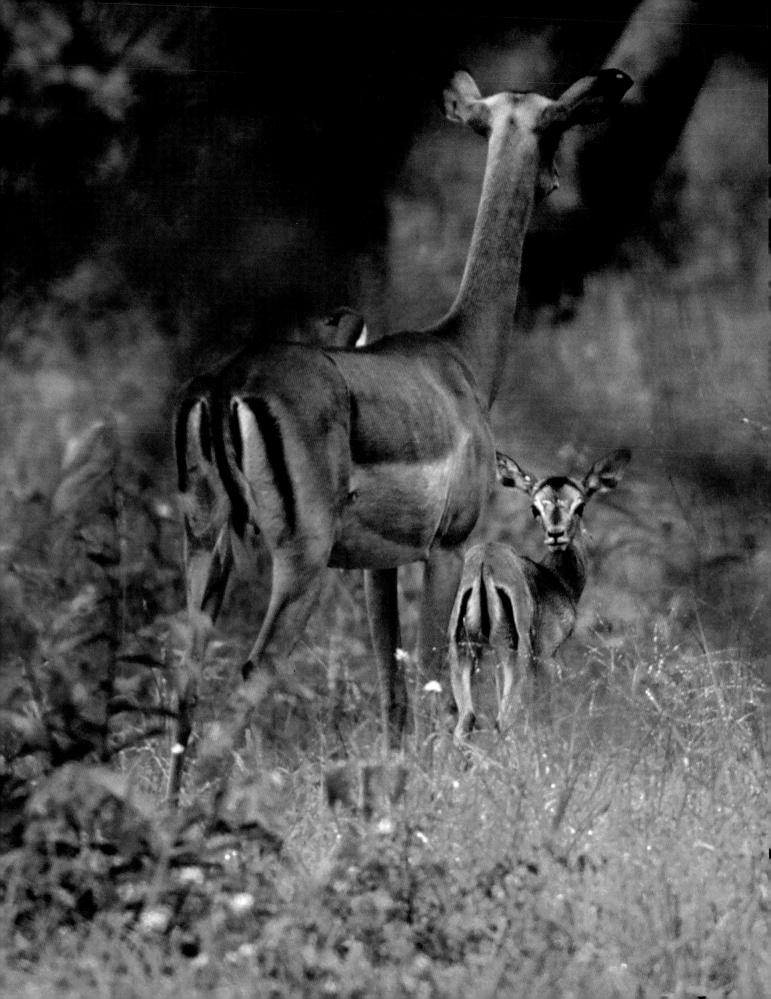

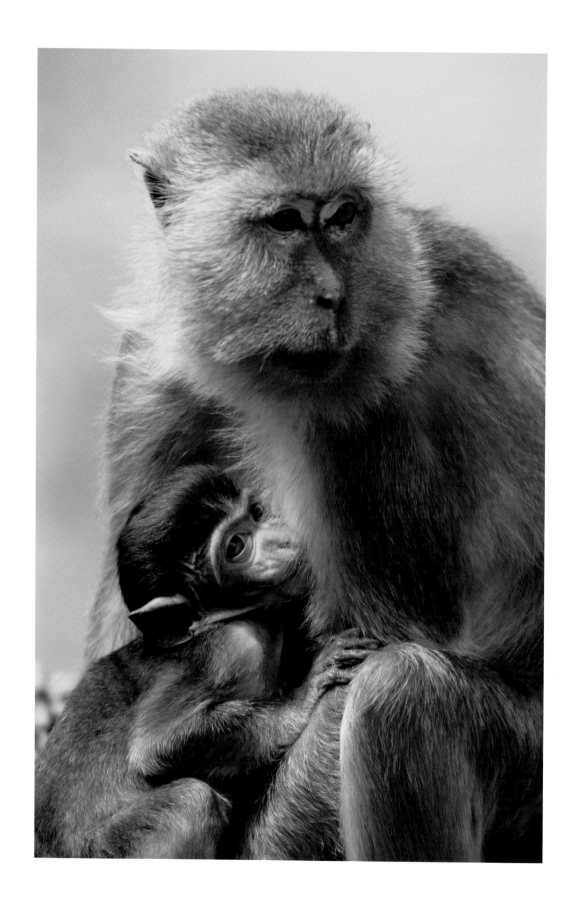

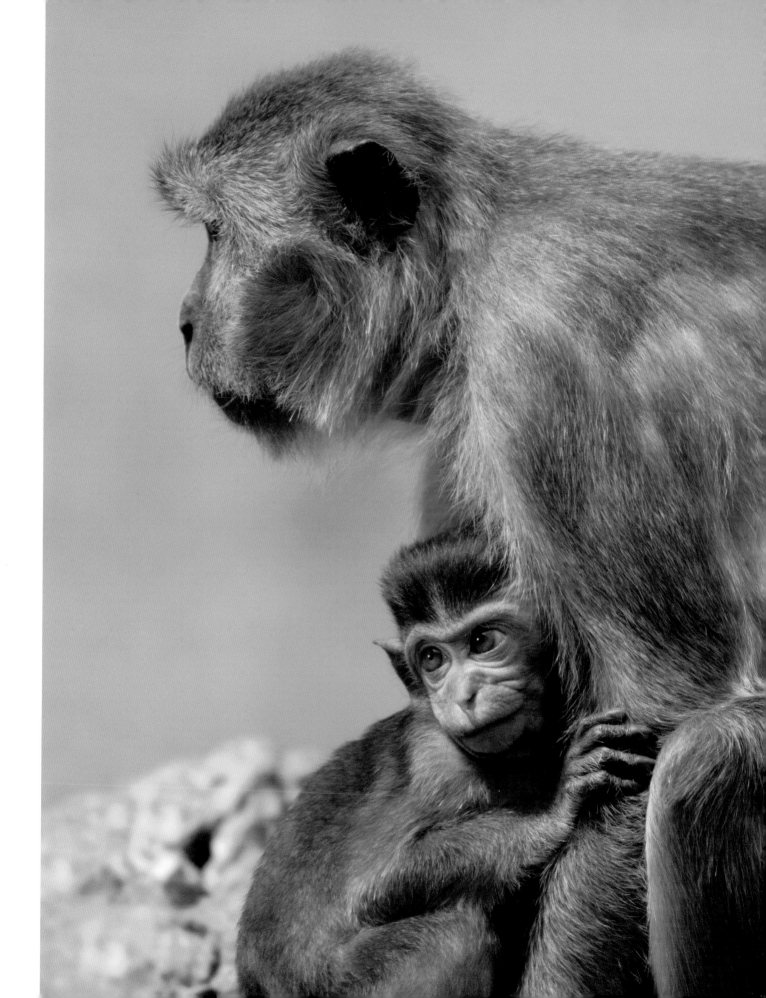

Previous spread, left to right: A crab-eating macaque *(Macaca fascicularis)* holding her vigilant and attentive offspring.

These crab-eating macaque monkeys are excellent swimmers, and often avoid predators by dropping into a stream, river, or waterhole and swimming swiftly away. Thus they prefer to live in coastal mangrove swamps and riverine forests, and inhabit Indonesia, the Philippines, Burma, Indochina, and the Nicobar Islands of India. They tend to sleep in the branches of trees.

Macaques live in troops which center around an alpha-female. They are omnivorous, and their food includes crustaceans (as the name indicates), insects, fruit, spiders, and buds. They have cheek pouches in which they can retain food.

After a gestation period of 5–6 months, the mother macaque gives birth to a single infant. They live only approximately 4 years in the wild but can live up to their late 30s in captivity.

At right: A common moorhen *(Gallinula chloropus)*, also known as a "marsh hen" or "swamp chicken," walks with her chick over water lilies on a natural pond in Queensland, Australia.

Moorhens are extremely vocal, and make a number of distinctive clucks and chattering calls as they move across swamps and waterways.

Each season they pair up monogamously, and the female and male usually share the incubation of about 8 eggs. They feed the babies on insects at first, before their diet expands to include vegetation and worms, etc.

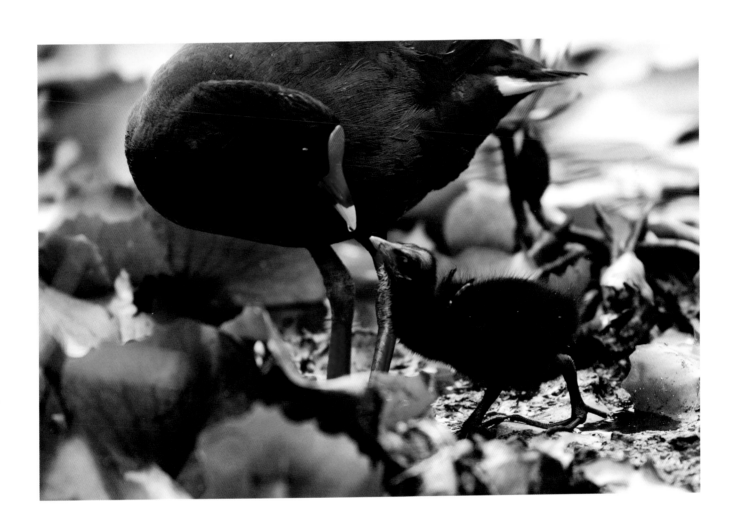

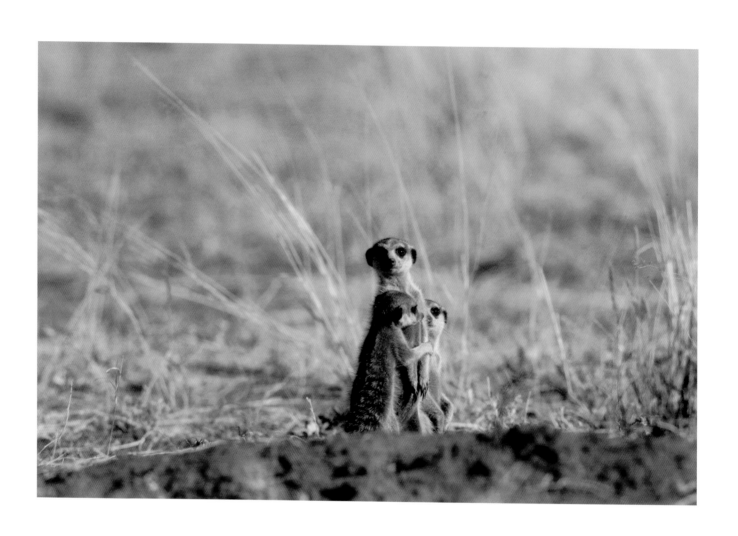

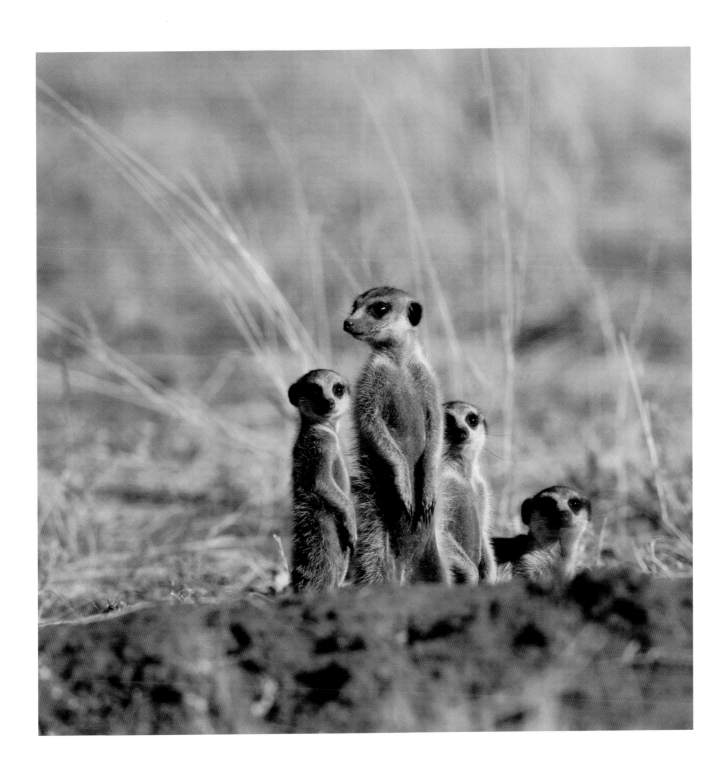

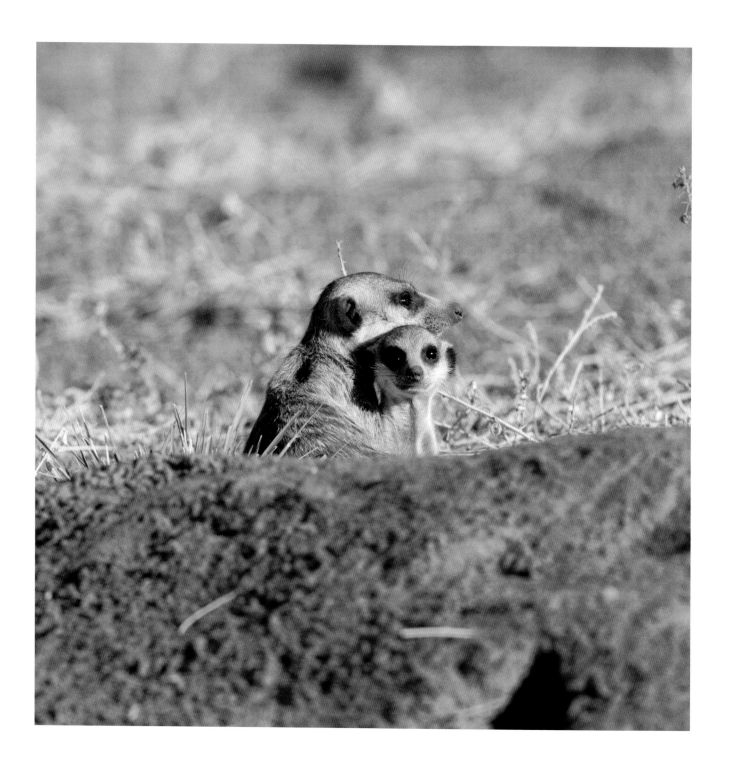

At left: A mother and baby meerkat in a charming pose in the southern Kalahari Desert, Africa. *Previous spread:* Grown-up meerkats *(Suricata suricatta)* and their young survey the scene outside their burrow in the Southern Kalahari Desert.

This burrowing member of the mongoose family is found in southwestern Africa, and their upright, sentinel pose is unmistakable. Their burrows have several levels of tunnels and chambers, with multiple entrances. The group, known as a "mob," spends the night in the burrow, and retreat to the underground passages to rest and avoid the heat of noon-time, after searching for food in the early morning. They forage again late in the day and often for many hours each day (up to 8) looking for beetles, caterpillars, termites, spiders, and scorpions, and even small snakes and rodents. They stand tall and gaze around frequently, watching for attack from jackals and raptors.

Meerkats are not quite a foot long when fully grown, and weigh less than 2 lbs. This appealing species has a pointed little face, open round ears, black eye patches, and a slender body with a black-tipped tail.

Meerkats live in family groups of 3–25, and will chase or fight strangers when they meet. In each mob there is a dominant male that tries to prevent other males from mating. There is also a dominant female that produces more litters than the others. In the wild, a female will bear two litters of 3–4 pups annually, and will give birth in the rainy season as a rule. The pups are born in the safety of the burrow.

Once out of the den, pups will follow the pack as they search for food, and helpers as well as mothers feed pups until they are many months old.

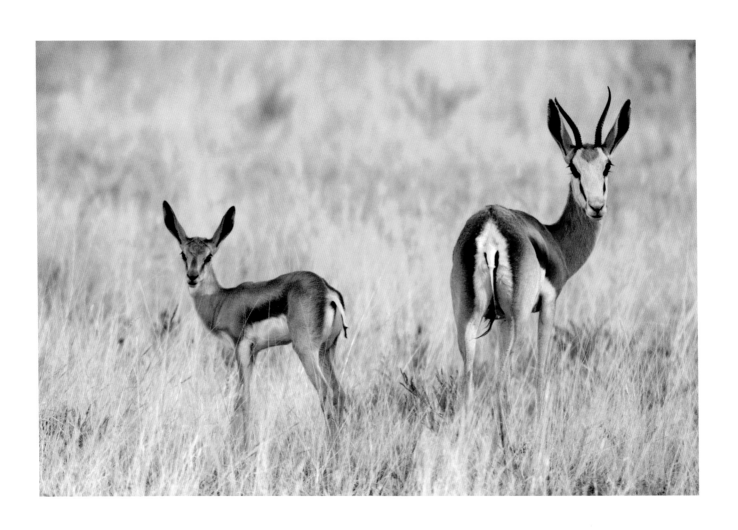

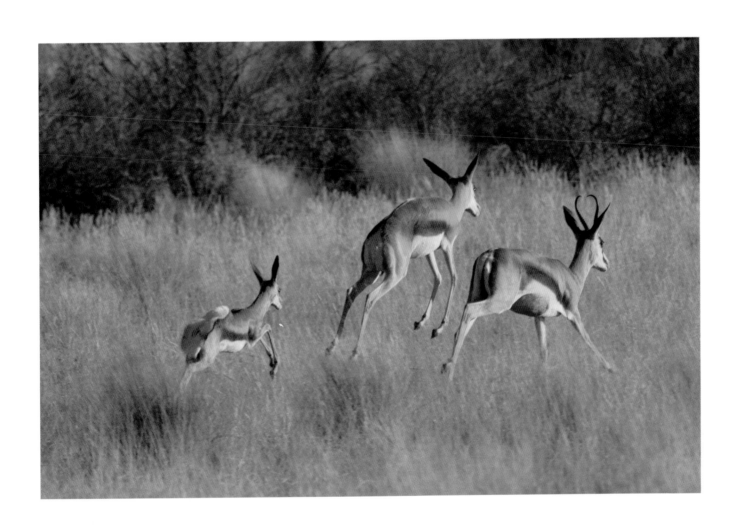

Previous spread, left to right: A springbok *(Antidorcas marsupialis)* and calf eye the camera in the grasslands of Mpumalanga (formerly Eastern Transvaal), South Africa; a family of Springboks on the move in Kruger National Park, South Africa.

This graceful, strikingly marked antelope is native to the open plains of South Africa. Its coat is a cinnamon color, with goodly areas of white on the head, underbelly, legs, and rear. Springboks bound along with all four feet simultaneously leaving the ground, reaching a startling height of up to 13 feet. This is known as "pronking."

Most young are born in the spring, shortly before the rainy season begins. A female springbok can conceive as early as 6–7 months of age, whereas males grow up more slowly and are not mature till around 2 years.

The springbok is the national animal of South Africa, and its name has been given to the national rugby union team.

At right: A capybara and pup *(Hydrochoerus hydrochaeris):* short haired and brownish with blunt snouts, they are the world's largest rodents, and native to Central and South America.

These group-dwelling animals have an average weight of 100 lbs when fully grown. They can also reach a length of over a yard.

The capybara is also known as a water hog, or a carpincho, and can swim and dive easily. It will enter the water to avoid enemies such as anacondas and jaguars. Capybara meat is edible and is marketed in places like Venezuela.

These huge, shy rodents gather in groups along the banks of lakes and rivers, where they spend their day resting. They normally feed in the morning and evening on melons and grain and vegetables.

A capybara will mate in the water, and mostly gives birth once a year to a litter of up to 8 pups.

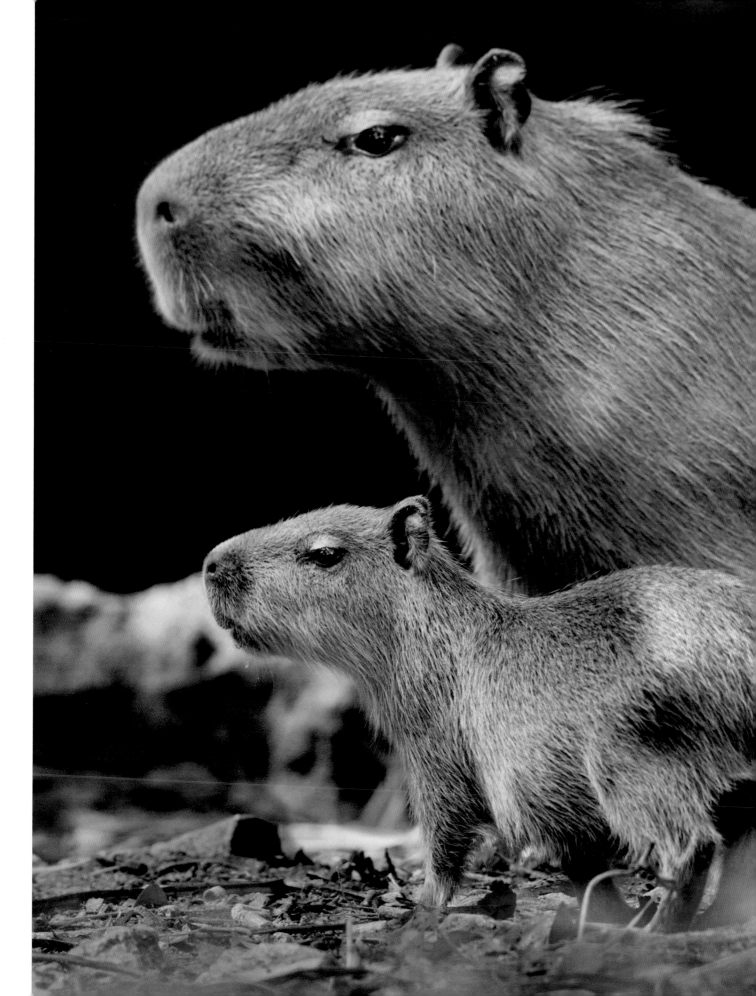

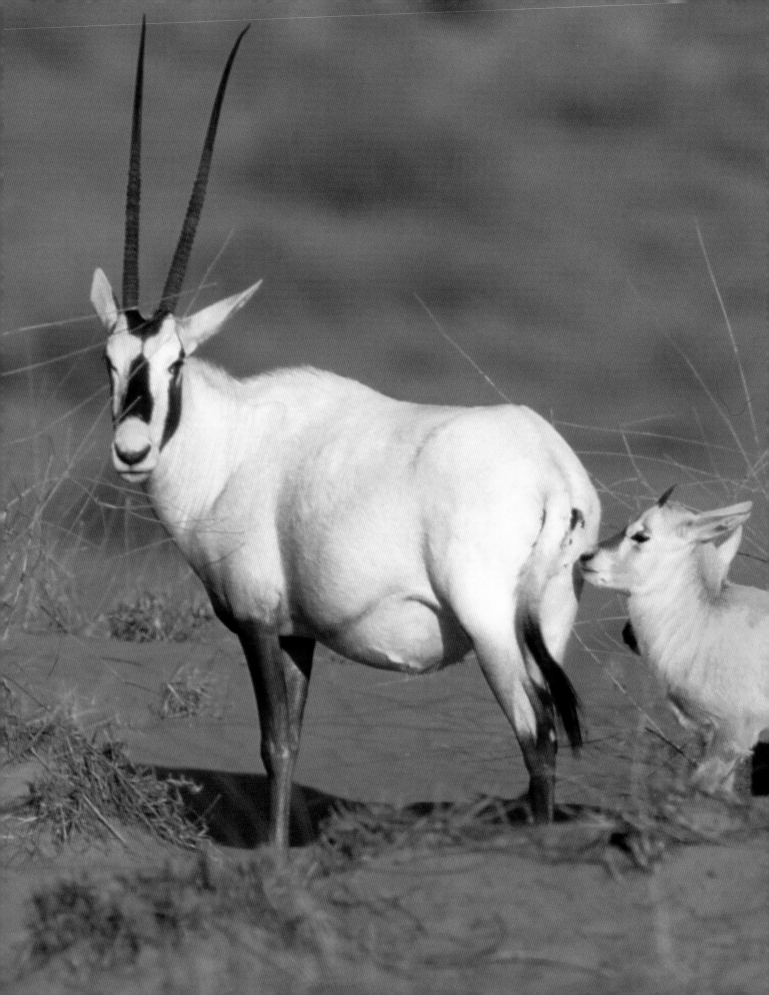

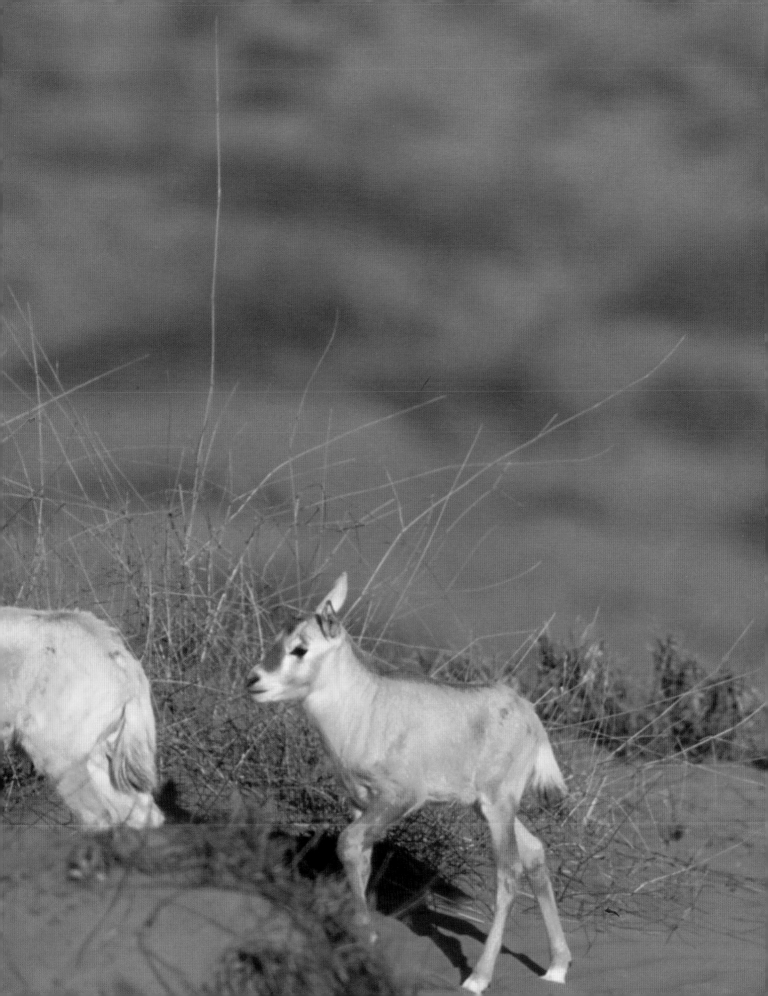

Previous spread: A mother Arabian oryx and calves *(Oryx leucoryx)* in the Arabian Desert. These nomadic dwellers have been reintroduced to the Arabian Peninsula, where their survival is dependent on effective protection from poachers. The Arabian oryx is listed as an endangered species. *At right:* In the desert of the Arabian Peninsula, an Arabian oryx stands in the sand with a young one feeding.

The Arabian oryx is built for the desert. Its bright white coat reflects the sun's rays, and its hooves are splayed and shovel-like, providing a goodly area on which to walk on sand. Their horns are long and straight, and they can go for long periods without drinking, though they drink regularly if water is available.

Oryxes are powerfully built and deep-chested, with blunt muzzles, relatively short necks, and long legs. Both sexes look alike, though the female is less muscular. In a herd of perhaps 10, only the dominant male breeds. After 8.5 to 9 months a single calf is born, gaining its attractive, grown-up face markings by the age of 6 months.

Following spread: The majestic great blue heron *(Ardea herodias)* rests with its chick in the lush foliage of southern Florida, USA.

A heron commonly stands at water's edge with its neck bent into an S shape, which smartly unravels when it lunges forward like lightning to catch a fish or other prey with its dagger-like beak. The blue heron is a particularly elegant bird that cruises the coastline with slow, deep beats of its wings, its neck tucked in and its delicate long legs trailing behind. Its plumage is a subtle blue-gray, and it has a white crown with a black stripe over its eyes.

They can be found in marshlands, open coastal waters, river banks, lakes, and even backyard ponds. For a whole season in Bermuda we had two resident blue herons at one end of our swimming pool.

Breeding herons gather in colonies, sometimes called "heronries," where they build nests of sticks and twigs high off the ground. The chick is a softer, more muted color than its mother.

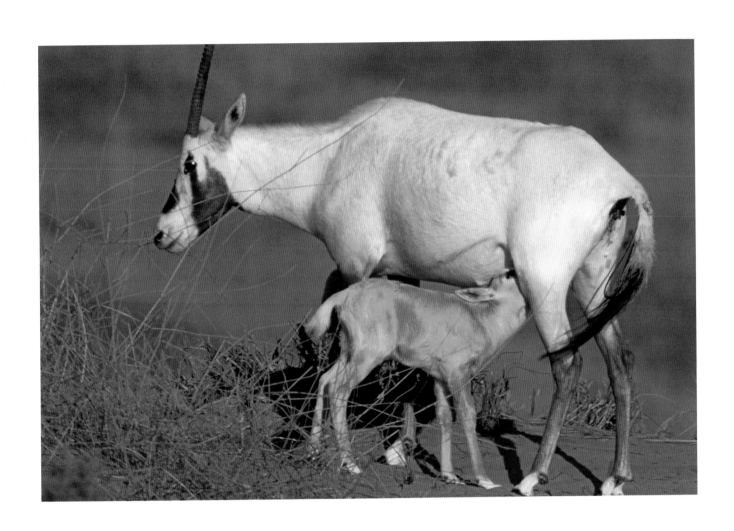

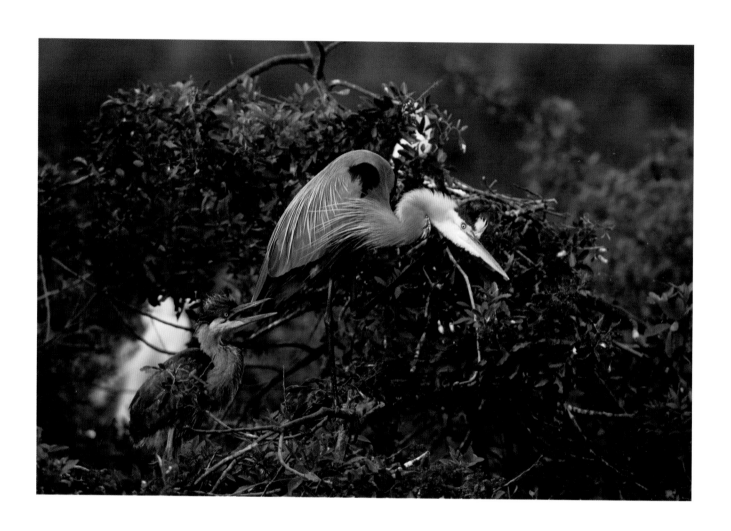

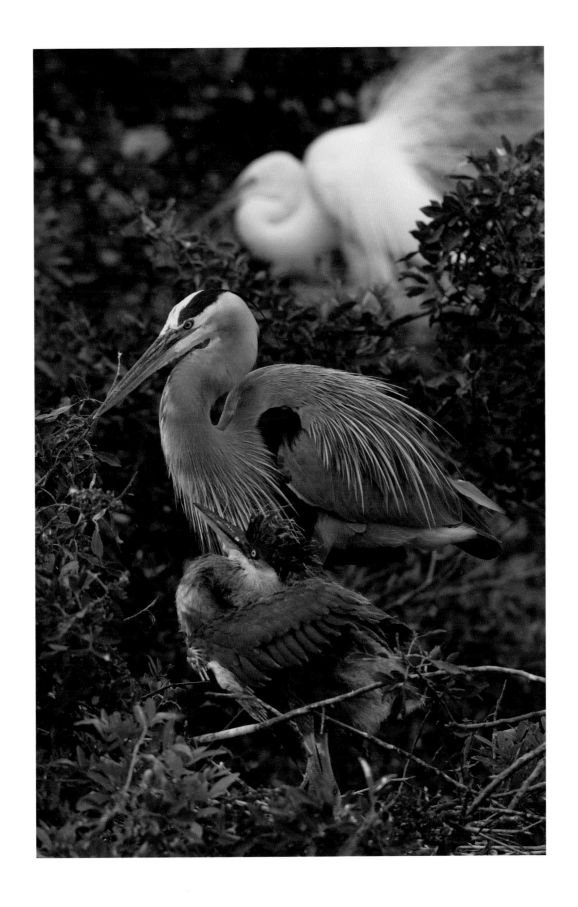

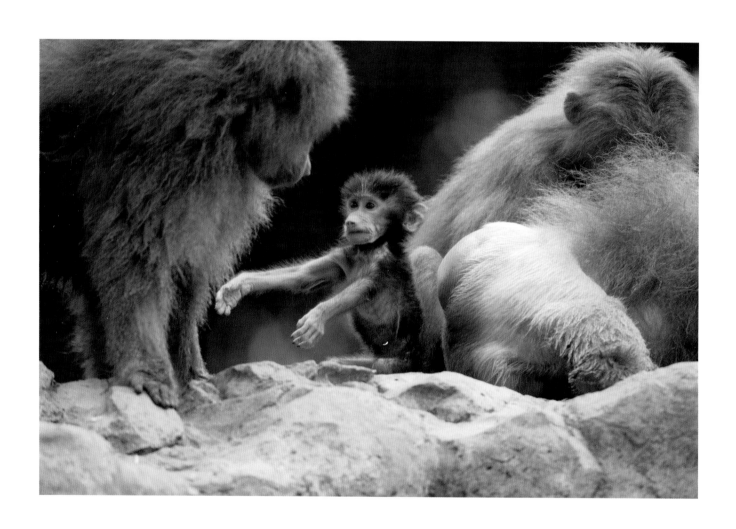

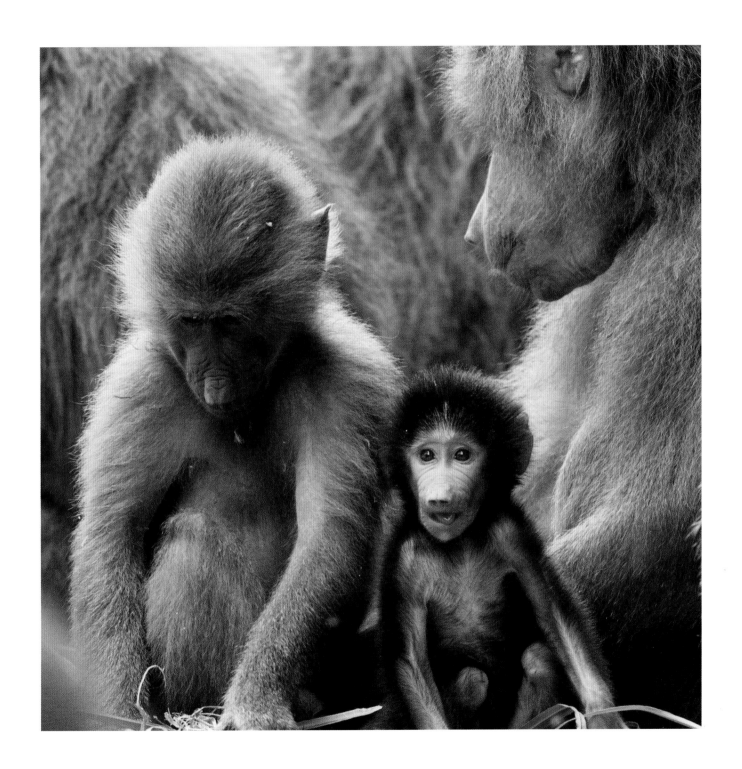

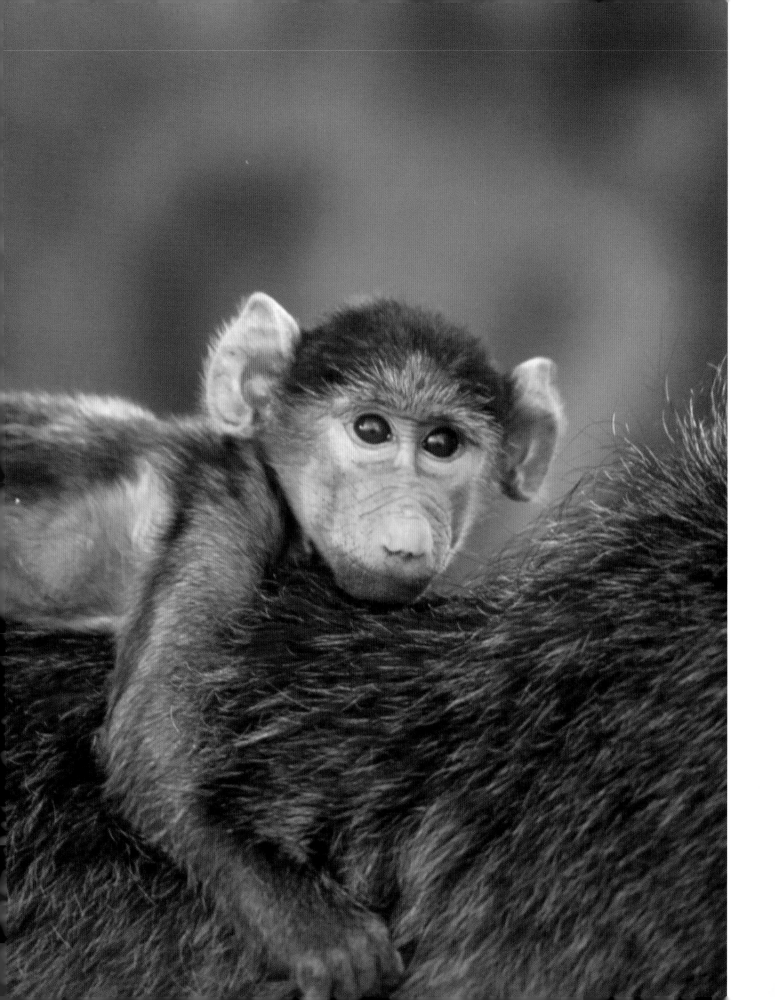

Previous spread and at left: Mother baboons *(Papio sp.)* with their young in the Cape of Good Hope, South Africa; a baby baboon eyes the camera while riding on its mother's back. This photograph was taken at dusk in the Kruger Park, South Africa, while a very large troop passed us by at a calm, walking pace. They moved along the crest of a hill about 75 yards away. There was not a lot of light, but I took this photograph using a Canon 800 lens with doubler.

Unlike most monkeys, few baboons live in tropical forests; rather they are mostly found in savannah country. They eat almost anything, with grass, grass-seeds, fruit, roots, rodents, and birds being their staple foods. They are intelligent and learn quickly, regularly coming into camp on safari and stealing sugar and food from tables when backs are turned.

Baboons live in groups known as troops, and grown-ups are often seen cleaning and grooming their offspring.

Within each troop there is a dominance hierarchy among grown males. They threaten and fight, and the ranking changes constantly. The female baboon develops a large, cushion-like swelling in its hind-quarters in order to make it attractive to males, who compete to consort with the female. The most dominant male mates with a greater number of females, and thus fathers a higher proportion of the next generation. After 5–6 months of gestation a single child is born to the mother. Babies are allowed a good deal of freedom in their behavior.

At right: A black-crowned night heron *(Nycticorax nycticorax)* and juvenile on watch for food near day's end in Bermuda.

Black-crowned night herons are stocky birds in comparison to their long-limbed heron relatives. They habitually come in the evening to our private beach, where they stand stock still, often in the water, until they pounce on their prey of small fish, crabs, and crayfish, which seem to be their favorites. They also eat snakes, rodents, insects, and occasionally plant matter, and have even been known to eat the chicks of other birds.

The juvenile of this species has a neck, chest, and belly streaked with white, with a brown head. It takes up to 3 years for a young heron to gain mature plumage.

There are about 60 species of heron, all wading birds, widely distributed over the world, but they are more common in the tropics. Like other herons, black-crowned night herons build nests of sticks and twigs over or near water, and this particular bird is probably the most widespread heron in the world.

Following spread, left to right: Barbary macaques *(Macaca sylvanus)* with babies.

Macaques are tail-less, ground-dwelling monkeys found in Gibraltar, Algeria, Morocco, and Tunisia. Grown males weigh about 35 lbs, and have powerful jaws and long canine teeth. Beside the lower teeth are cheek pouches that extend down the side of the neck, where they store food when foraging. The volume of food held in these pouches can equal that of the stomach.

Females and males mate indiscriminately, so there is no certainty of paternity. A single baby is born after a gestation period of about 5 months, and pregnancy can occur every 1–2 years.

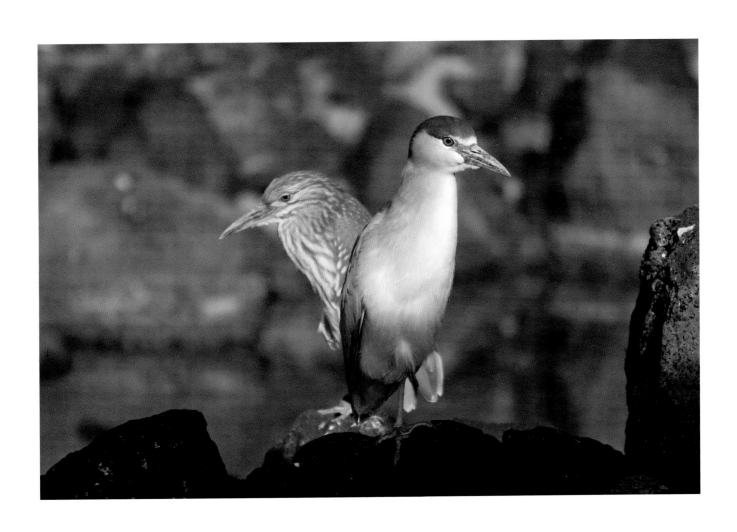

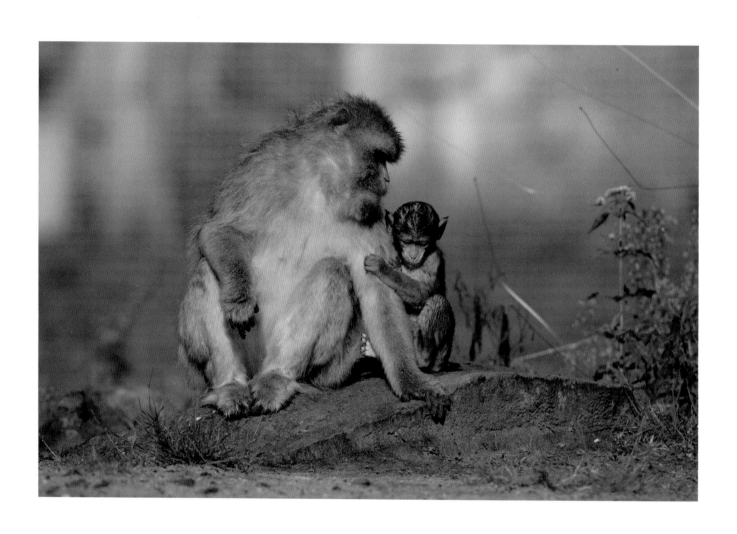

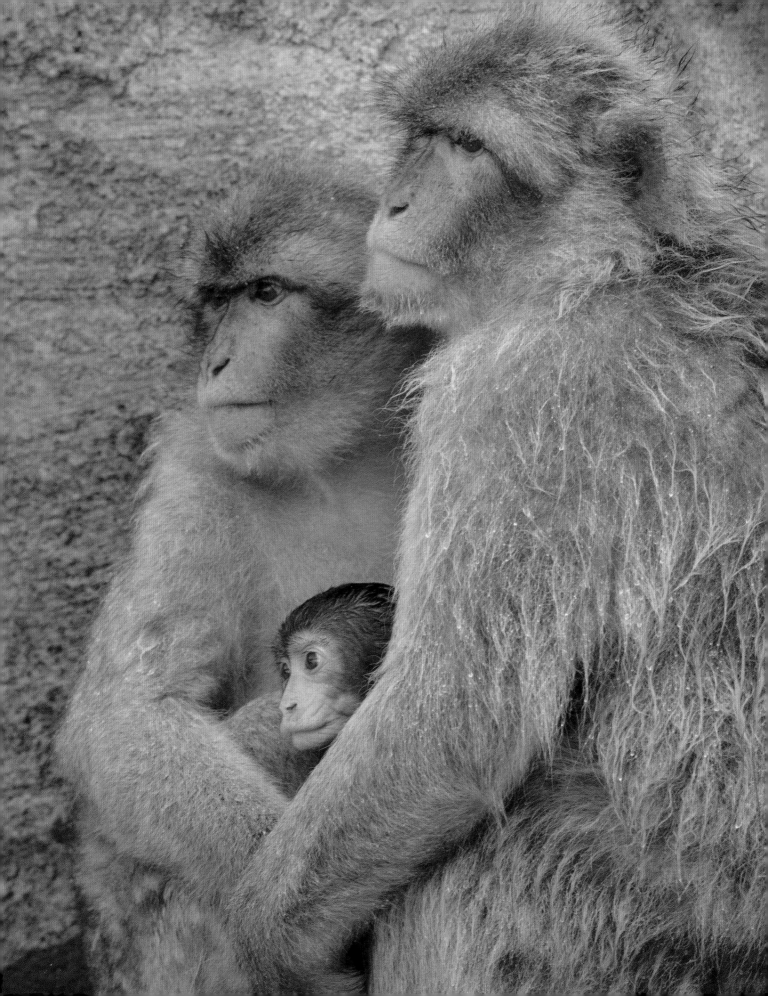

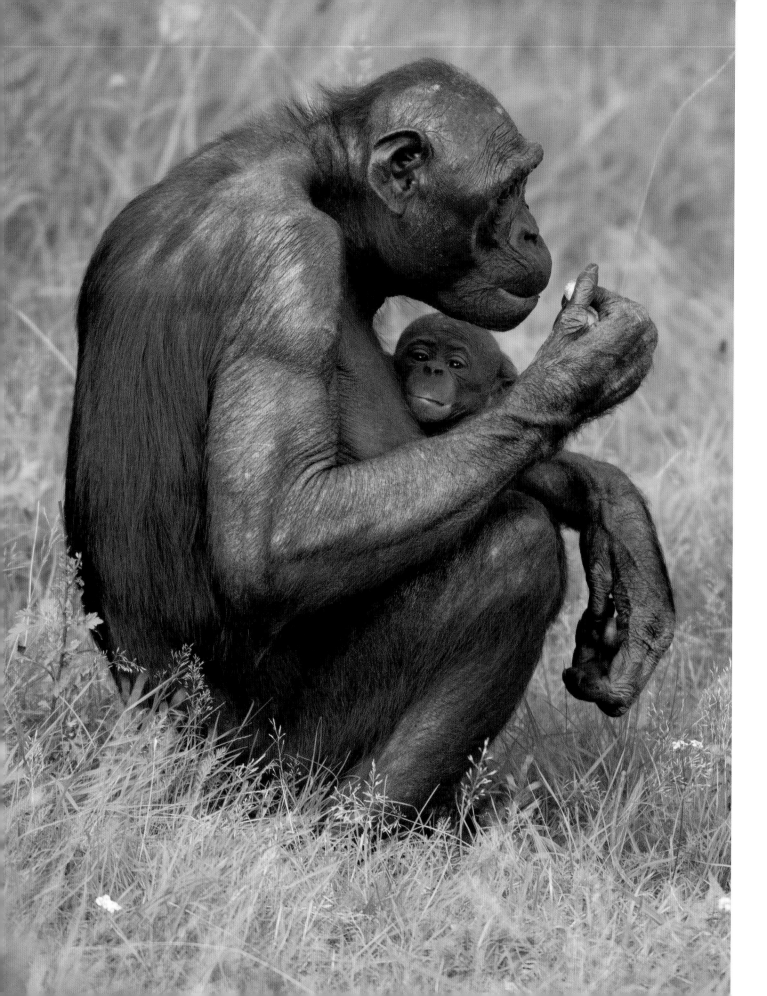

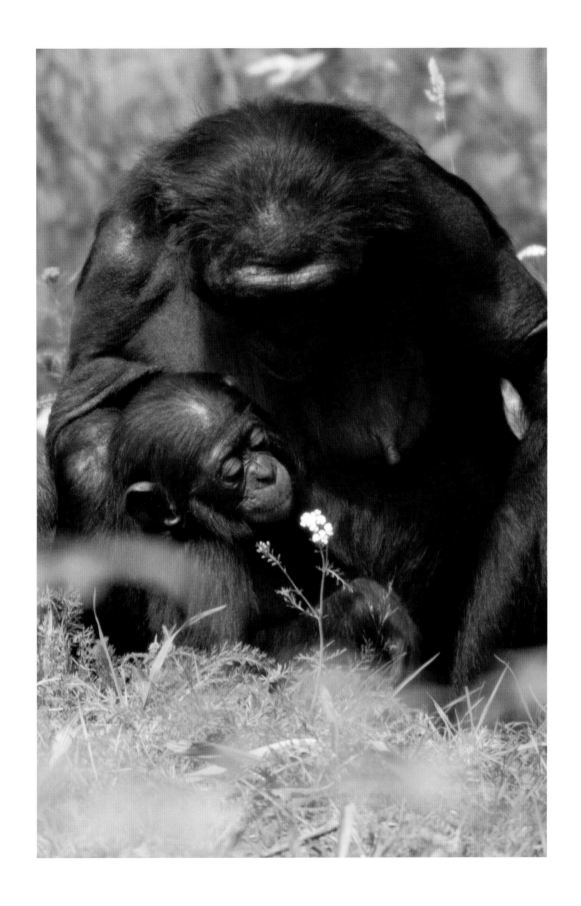

Previous spread, left to right: A mother and baby bonobo *(Pan paniscus)* lovingly forage in the long grass. *At right:* A happy bonobo baby, its eyes gleaming with interest, looks over its mother's shoulder.

These great apes are native to only one country of the world, the Democratic Republic of the Congo, and live only in the lowland rainforest along the banks of the Congo River.

Bonobos have the distinction of being one of mankind's closest relatives, along with the chimpanzee (98% of our DNA is shared by these great apes). As with humans, a single baby is usual, after approximately 8 months of gestation. They are intelligent, with a deep emotional capacity, and in captivity have learned how to use tools as well as rudimentary language skills.

Different from chimpanzees and their male-dominated, aggressive society, bonobos are peaceful, and their communities matriarchal—the females having a higher social status than males. They have pink lips and black faces, and their black hair parts naturally down the center of their heads.

Fruit is their staple diet, but they will eat insects, earthworms, eggs, and sometimes small mammals.

Large communities of perhaps 100 will often divide into smaller parties during the day to search for food before they rejoin to sleep together at night.

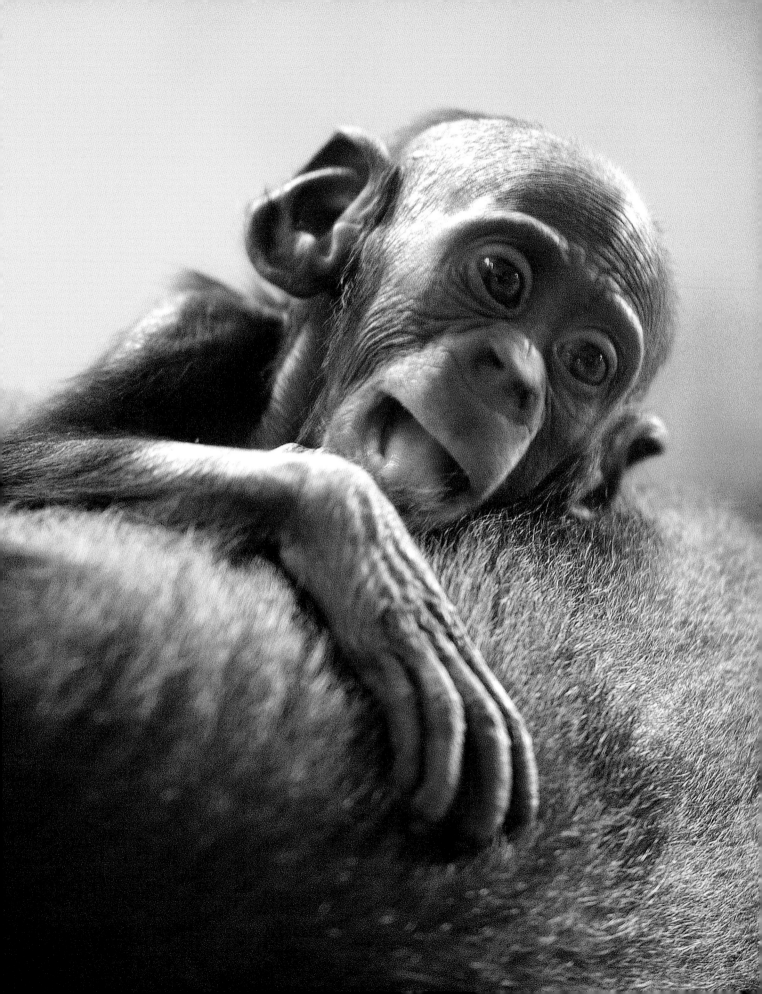

Previous spread, left to right: A sulphur-crested cockatoo *(Cacatua galerita)* feeding its baby on a dead tree in rural Queensland, Australia.

Both sexes incubate a clutch of 2–3 eggs, which rest in hollow limbs or high up in trees (usually eucalyptus) and near water. Hatching takes place after 25–27 days. Nestlings remain in the nest for 9–12 weeks, again being cared for and fed by both parents.

These cockatoos are intelligent and learn to talk easily, and long life is normal, some living many decades, even up to 70. They often form large flocks of several hundred birds and can be noisy and even destructive.

Their habitat is in sparsely timbered country throughout Australia's northern, eastern, and southwestern districts.

At right: A California quail *(Callipepla californica)* with a clutch of chicks, near woodland in Northland, New Zealand.

California quails are short-tailed game birds that resemble partridges but are generally smaller and less robust. They are found in the western United States, British Columbia Canada, and New Zealand in the brush and scrub, as well as the open stages of conifer.

In spring the hen nests in a small depression in the ground, and incubates around 12 round eggs for about 22 days, while the male helps in this task by staying nearby. The young remain with their parents for the first summer.

Quails prefer to live in open country, and their eggs and flesh are considered a delicacy.

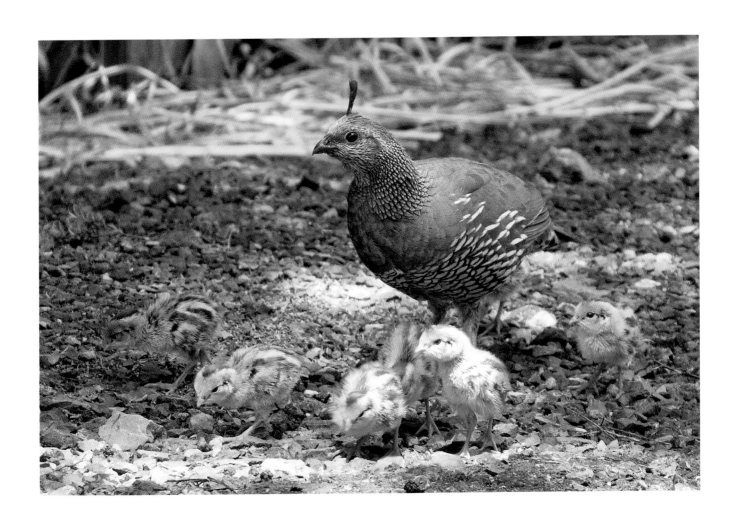

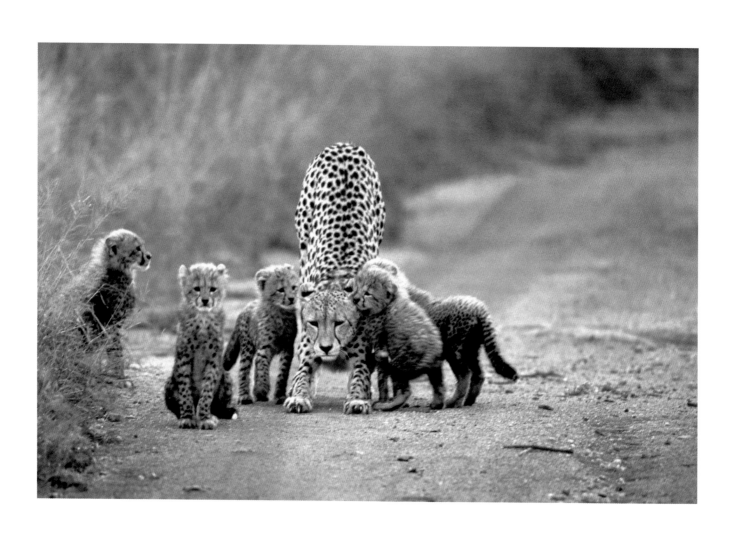

At left: A mother cheetah *(Acinonyx jubatus)* with her litter of 5 on a road in Kruger National Park.

I was in our 4-wheel drive, rushing to Skukuza Airport to meet my wife, Joy, who had left earlier, when suddenly, directly in front of the vehicle on the road, we came across this mother with her babies. We stopped and I began to shoot film as fast as possible while the family group displayed affection. It was one of the shortest sessions of photography I have ever enjoyed, and yet this picture, which has such verve and is one of my favorites, came out of it.

Following spread, left to right: A cheetah mother and cub watch me intently in the morning light; cheetah grooms her cub; cheetah and juvenile trio; *page 64:* dusk on the veldt.

The cheetah is the fastest land mammal on the planet, reaching speeds of over 50 mph, and the adult cheetah can weigh up to 140 lbs.

The average litter is larger than that of other big cats, and while 3–4 offspring is normal, there have been up to 8 recorded.

This beautiful, sleek feline's distinguishing facial markings are the black lines, which run vertically. Her coat is yellowish with distinct black spots, and her underbelly is white. The name "cheetah" derives from the Hindi meaning "spotted."

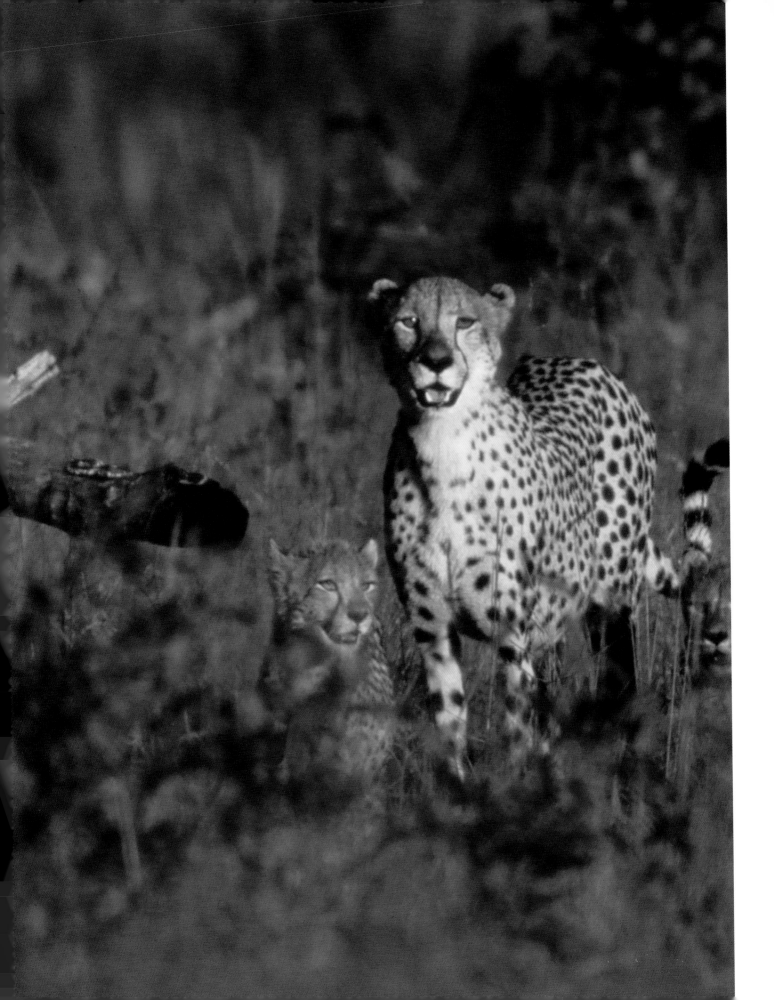

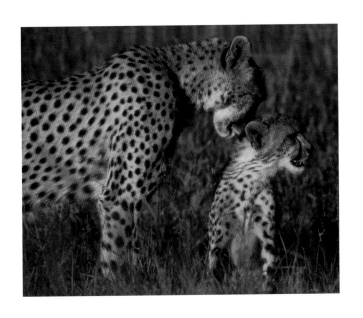

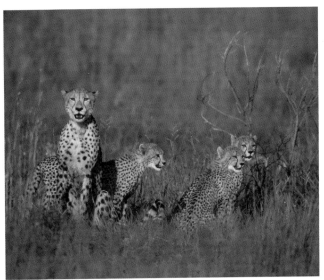

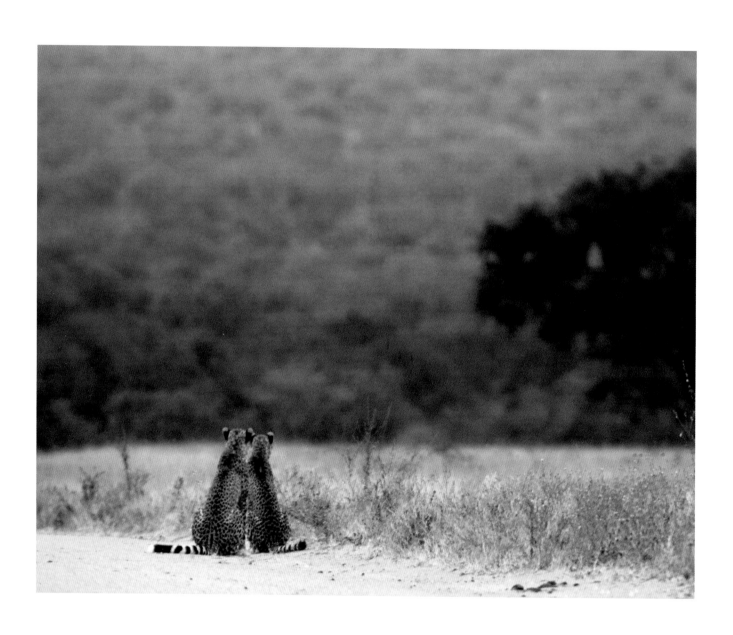

At left: I took this photograph of two young cheetahs sitting shoulder to shoulder looking into the distance of the African bush after a "chiding" from their mother.

The big cats of Africa often gravitate to the small airfields which dot Kruger National Park. The animals have unfettered vision from the clearing and can see prey in the distance. It was early evening and we had been in the four-wheel-drive vehicle for over an hour. Here we were enthusiastically watching an event we had never seen before, involving these two juvenile cheetahs and their mother. The mother cheetah was obviously training her two youngsters to chase after quarry. The mother would run in short bursts, and they would follow. Over and over they did this. Sometimes the young ones would head off into the grass, where she followed them, reprimanded them (it appeared to us), and brought them back for more training. It was enthralling to watch.

Suddenly the mother cheetah stiffened, spying two warthogs in the grass in the middle distance, and, as if saying, "Well go on, now is your chance, show me what you've learned," she urged them to chase the prey. Off they both ran, amateurishly straight at the warthogs, which easily eluded them. The mature animal's disgust was almost tangible to us.

When the two young cheetahs returned to their mother, it was again as if we could hear her berating them, "Well you made a mess of that." Their reaction was to move away from their mother and sit together disconsolately, shoulder to shoulder, on the edge of the airfield. We imagined they were commiserating with each other. That is when I took this photograph.

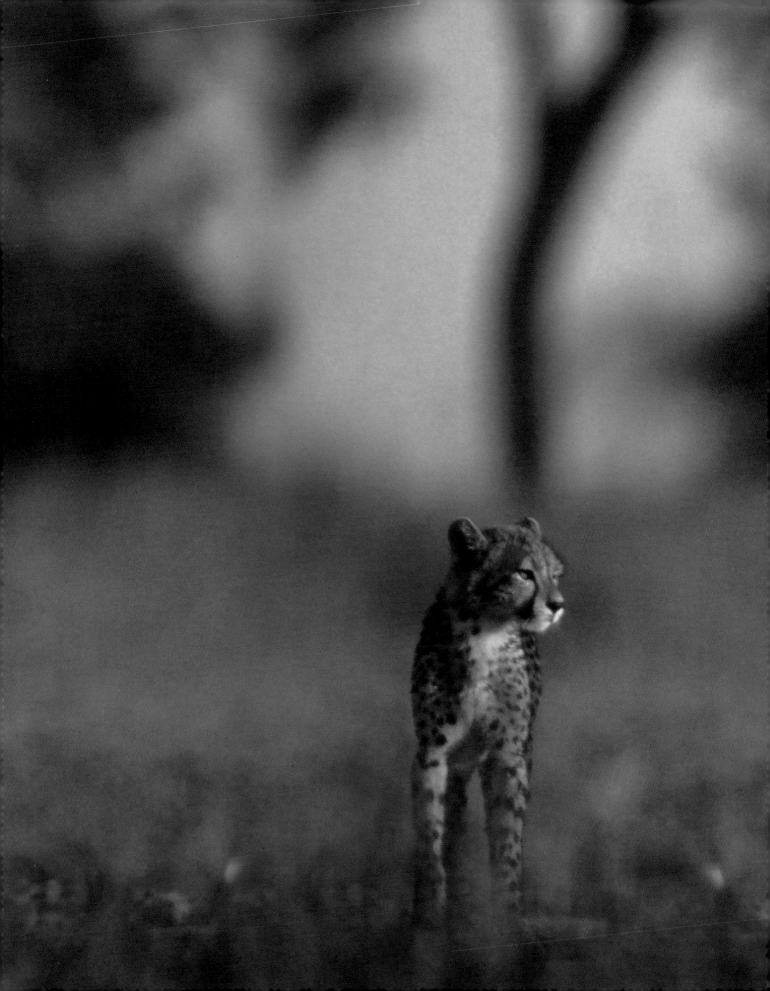

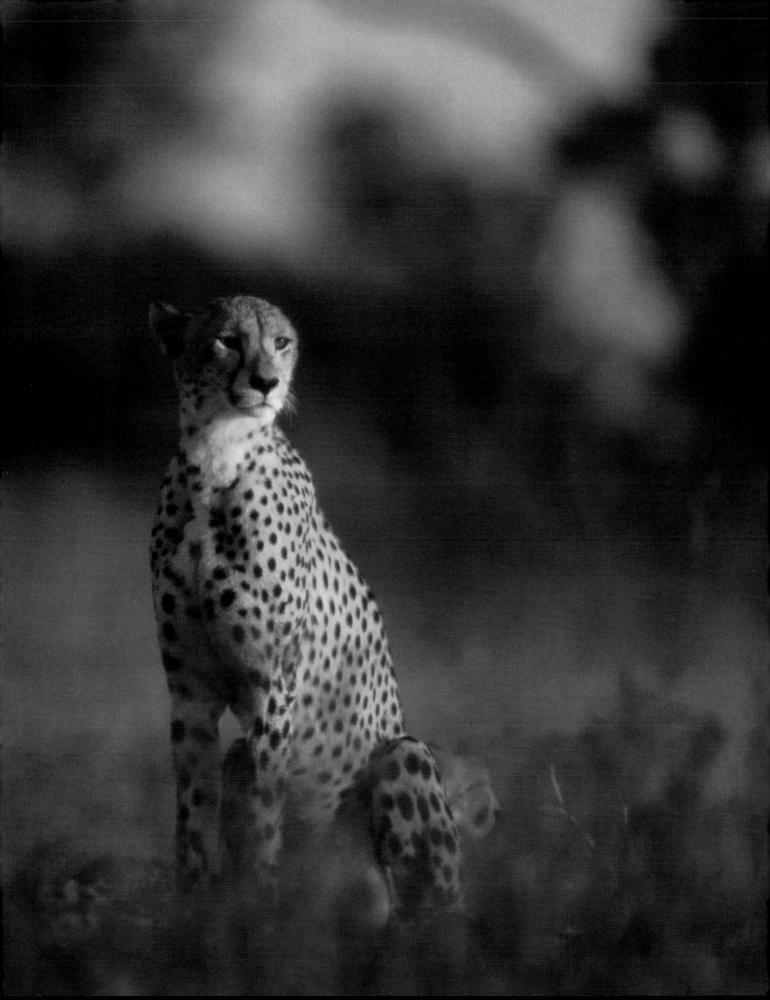

At right: West of Brisbane, Queensland, Australia, a mother koala *(Phascolarctos cinereus)* intently watches the camera while a baby joey nestles in her arms.

Like other marsupials, the female koala has a pouch with a powerful muscle to prevent its young from falling out. Births are single, and the joey puts its head out of the pouch after about 5 months. The joey is weaned on a soupy predigested eucalyptus, called "pap," which is lapped by the baby directly from the mother's anus.

The species survives on a diet of eucalyptus leaves and receives 90% of its hydration from them. Usually an individual koala will have a favorite tree. It drinks water when ill or during a drought, when the leaves of the eucalypt don't carry enough moisture. As a result of this relatively poor diet, the animal has little spare energy, which forces it to spend long hours sleeping in tree forks, exposed to the elements but protected by its thick fur.

Virtually tail-less, the body is stout and mainly gray. It has a leathery nose and a broad face similar to a bear, hence the title "koala bear."

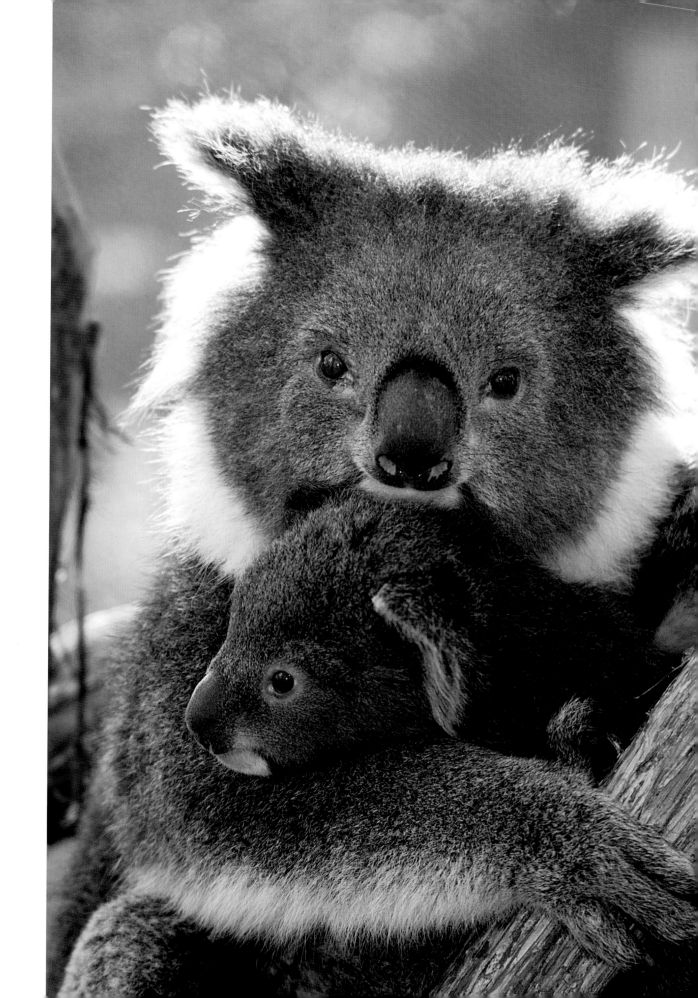

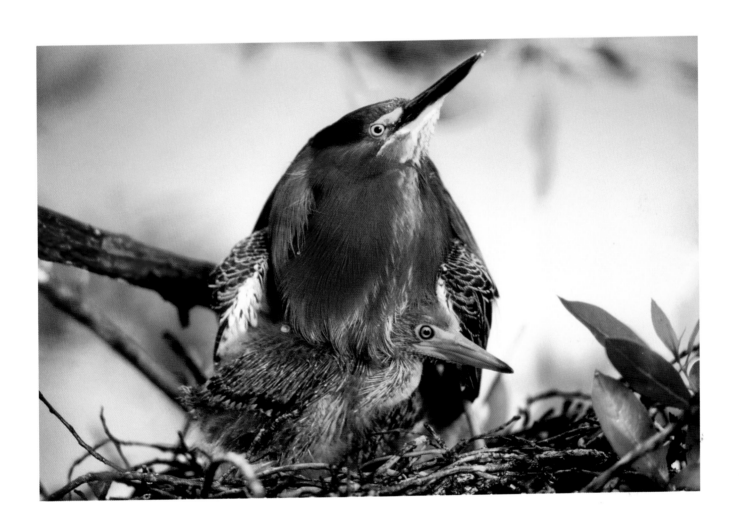

Previous spread, right to left: A green-backed heron *(Butorides striata)* with her young chicks in the swampy wilds of Florida.

This mother had three chicks, and her voluminous red breast of feathers at times hid them completely. Every now and then a tiny fluffy head would appear out of the russet feathers and look around.

The red-backed heron may breed up to 3 times a year, and the nest is constructed in trees or bushes that overhang water. A usual clutch of eggs is comprised of 3 to 5, and they take about 3–4 weeks to hatch. Both parents feed the young.

This species has been known to use an ingenious fishing technique called "baiting," where it drops insects onto the water to attract its fish prey. The bird is often seen on low branches jutting out over water, where it perches, crouched and still, patiently awaiting unsuspecting fish before using its dagger-like beak as a spear.

At right and following spread: Red-shanked douc langur *(Pygathrix nemaeus)* and babies, high in the trees. Reminiscent of elderly men with their white beards, these colorful primates with their long red "socks" inhabit Vietnam, Laos, Cambodia, and parts of China.

In the wild they remain in the forest canopy and feed on leaves, seeds, fruit, and flowers.

Gestation is around 6 months, and motherhood is a shared duty within the group, where social bonds are important. They communicate vocally and visually, and social grooming is common. Their lifespan is about 30 years.

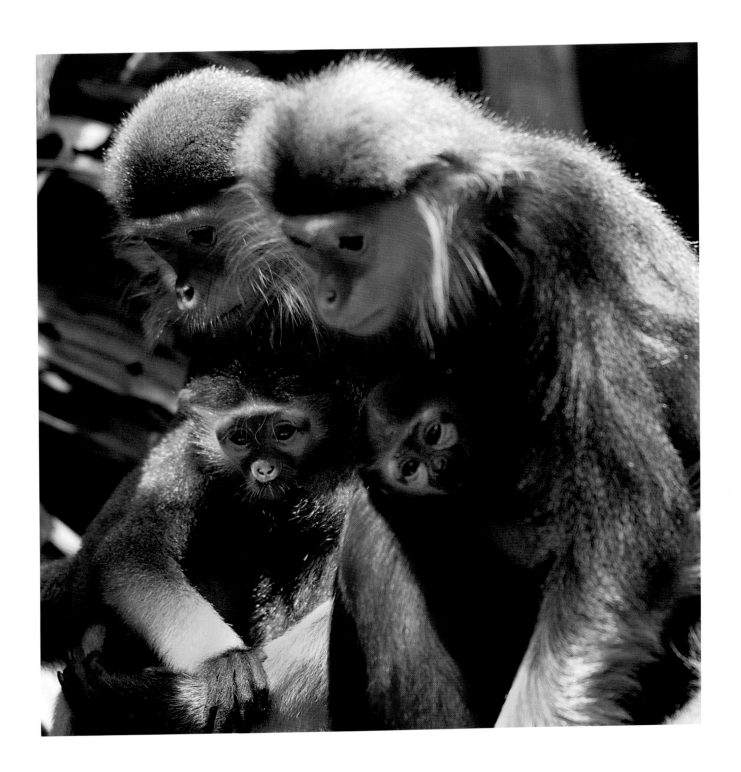

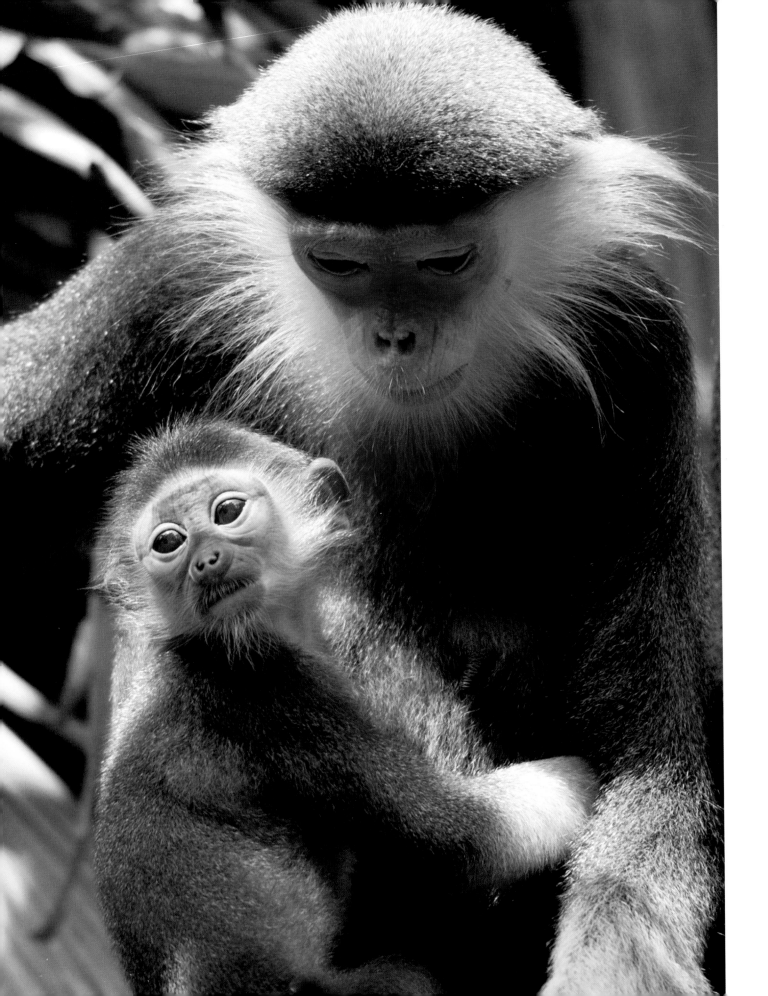

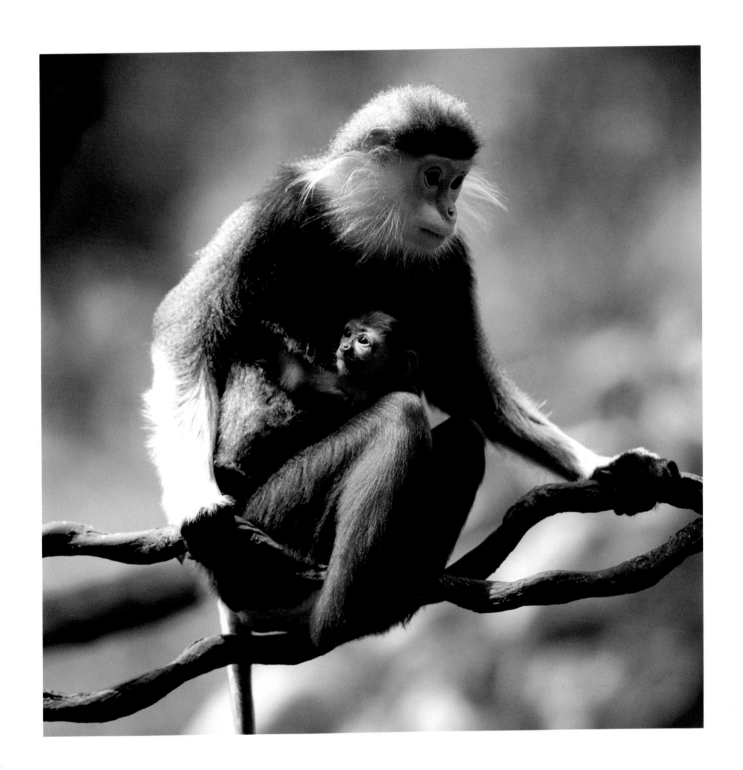

At right: An African Cape buffalo *(Syncerus caffer)* and its calf eye proceedings while bathing in the morning light. Although they have relatively short legs, these formidable bovids are massive, and weigh well over half a ton.

They thrive in all sorts of grasslands and often gather in large groups near or in water. Because of their bulk, these ruminants must eat large amounts of grass, and they can tear grass that is coarse and tall using their row of incisor teeth.

Unusual for African ruminants, they will lie together touching, and clans of related females and offspring are known to associate in sub groups from the main herds. Herds are an average of 400, and will cooperate to defend members from the big cats—they have even been known to kill lions.

Following spread, left to right: Ducks *(Anas sp.)* and ducklings in spring, on a New Zealand waterway near Hamilton. A duck is a short-necked, large-billed waterfowl.

Unlike the late-maturing and life-mating geese and swans, all true ducks (except for sea ducks and those in the shelduck group) mature in the first year, and pair only for the season.

Ducks have a distinctive waddling gait as a result of their rearward-placed legs.

Female ducks produce large clutches of smooth-shelled eggs, which take an average of 4 weeks to hatch.

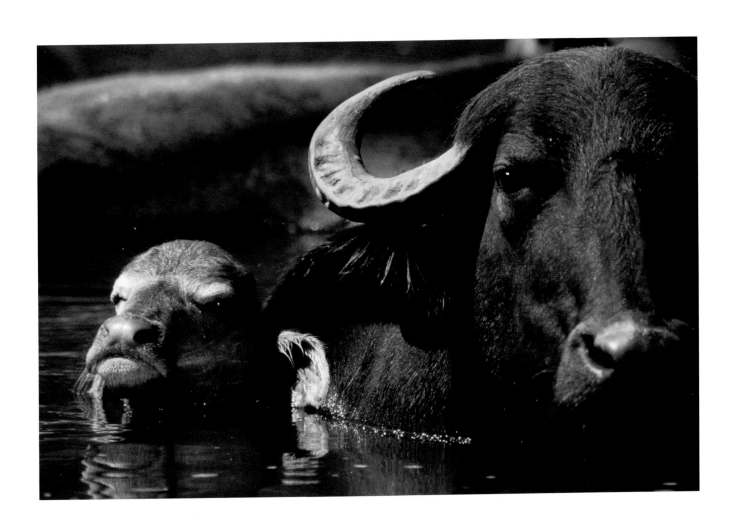

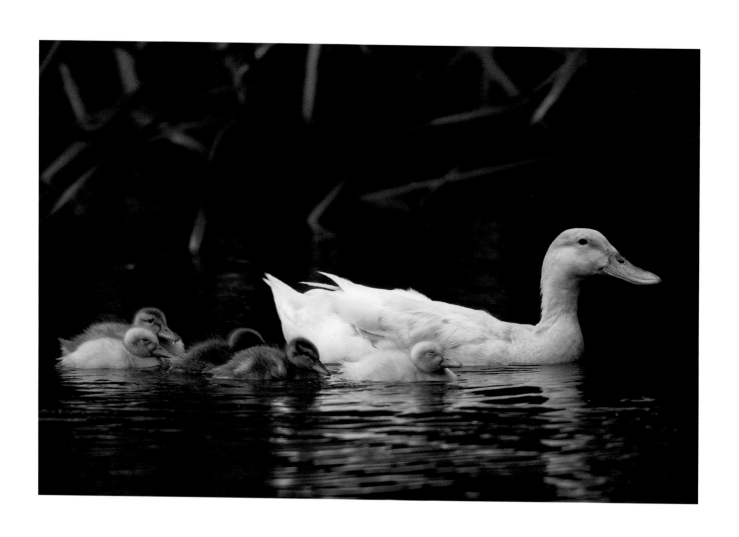

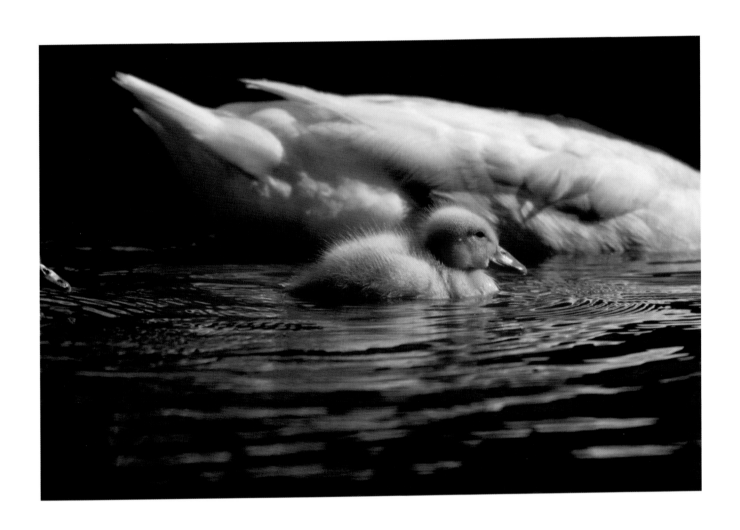

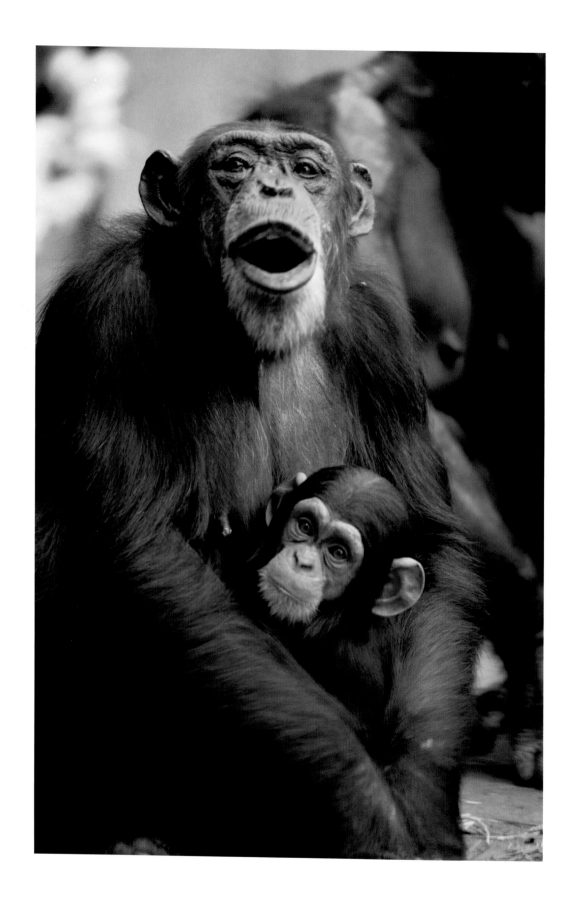

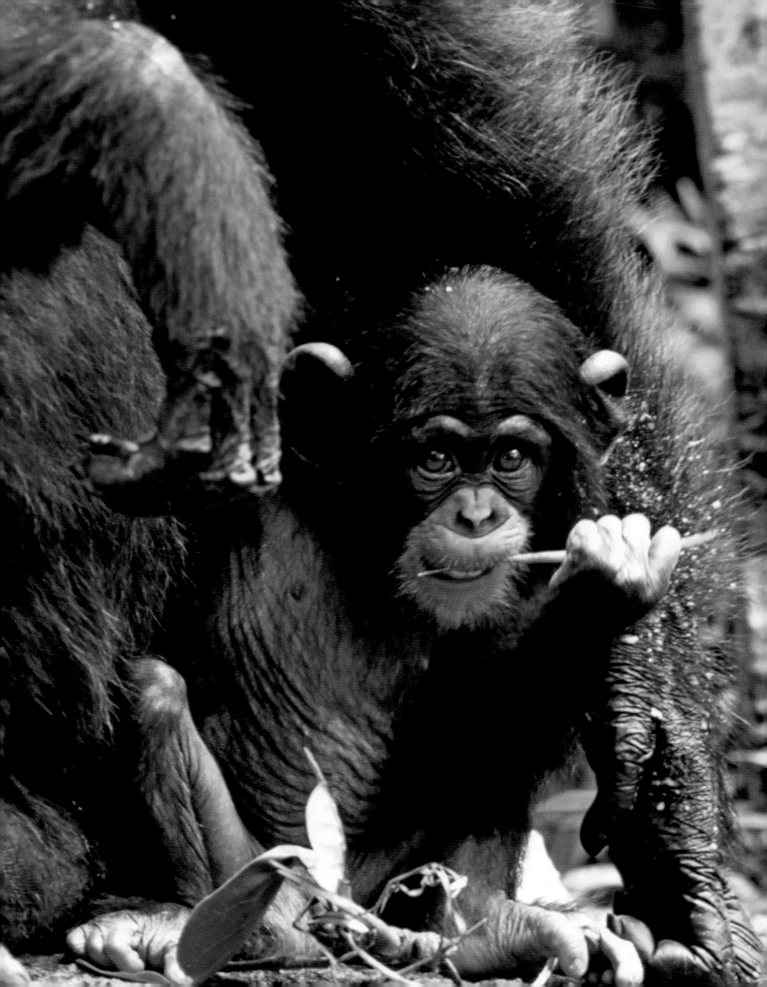

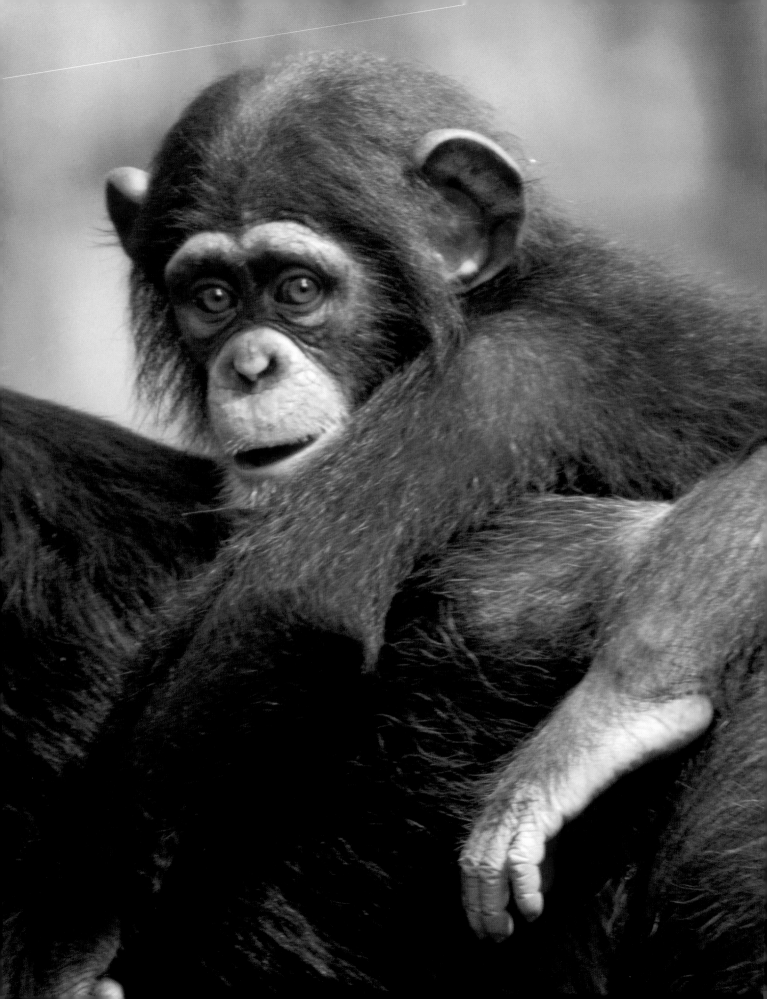

At left, preceding, and following pages: Chimpanzees
(Pan troglodytes) grooming and nurturing their young.

This primate, along with the bonobo, has the distinction
of being the most closely related to humans.

Chimpanzees inhabit the savannah lands and tropical
forests of equatorial Africa. Their faces are bare except for
their short, white beards. Babies, as can be seen in these
pictures, have pinkish skin on their faces, and act in a very
human baby manner. From around 6 months to 2 years,
the baby rides on the mother's back. Weaning usually takes
place at around 5 years, and males are considered grown-up
at 16, while females usually begin to reproduce at 13.

These great apes can walk upright, but they prefer to move
about on all fours, leaning on the knuckles of their hands.
They awaken usually at dawn and spend the day in their
communities on the ground and in trees. The late afternoon
is the intensive-feeding period for a chimpanzee.

Their lifespan in the wild is about 45 years, and close to 60
in captivity, though older individuals have been recorded.
Cheetah, the animal actor from the black-and-white *Tarzan*
movies, is said to have lived to be 80.

Chimpanzees are intelligent and have been documented
using tools of a kind (rocks to crack nuts, for example).
Females spend most of their time with their young or other
females. The adult male will dominate the adult female.

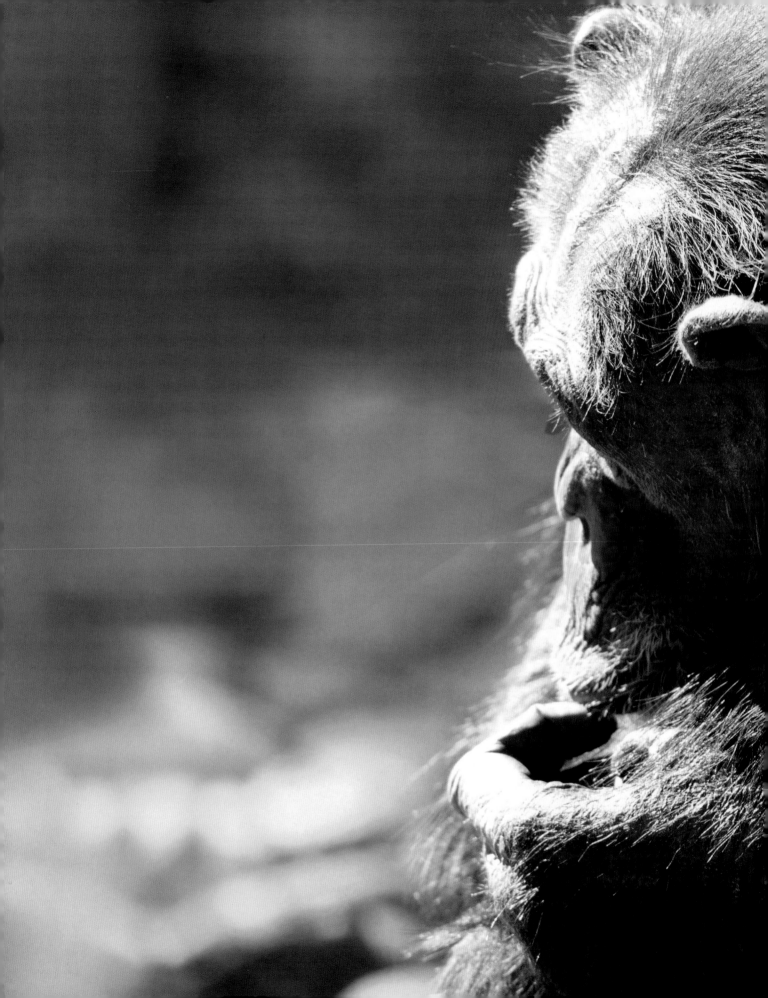

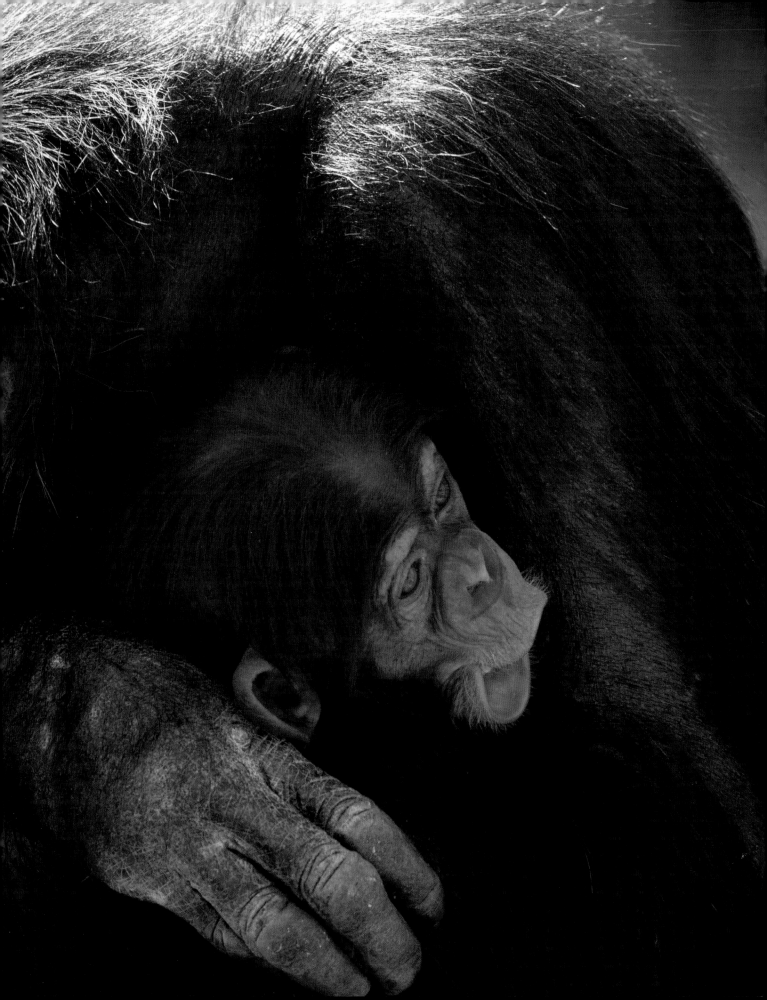

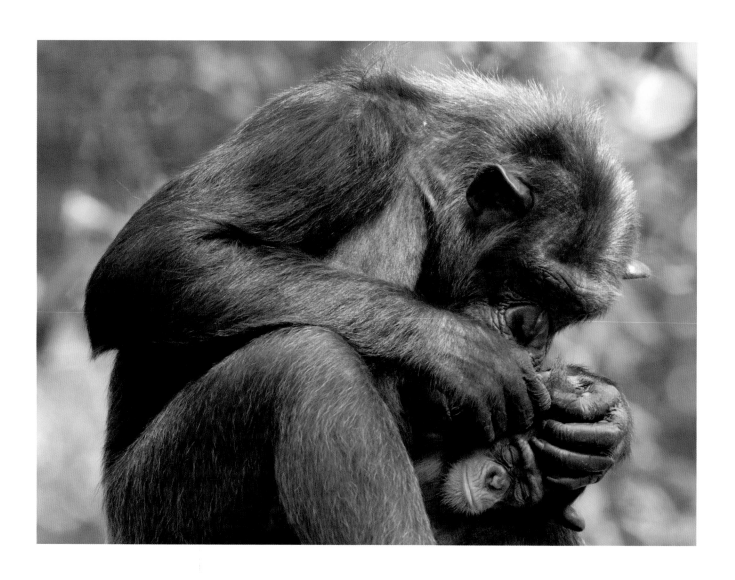

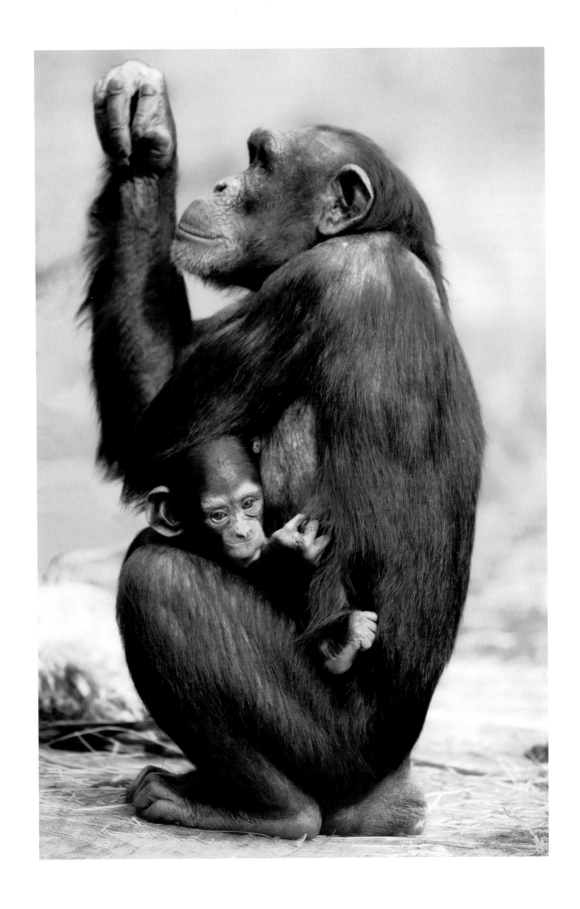

At right: A paradise flycatcher *(Terpsiphone sp.)* feeds its hatchlings in the African forest.

Many paradise flycatchers have crests and eye wattles, and some breeding males grow elongated tail feathers. They are, as their name suggests, insectivores, and they feed on a variety of different insects, often caught on the wing.

Flycatchers are monogamous and generally territorial, though in certain cases nests have been built close together and defended in a group against predators.

Following spreads: Gray or Hanuman langur monkey *(Trachypithecus sp.)* families in Ranthambore, India.

Langur is the general name given to numerous Asian monkeys of the subfamily Colobinae. Langurs are diurnal and gregarious. Countless family groups of langur abound in India, and they are not intimidated by humans. While we were travelling in India, families of langurs daily mounted the bonnet of our vehicle to greet us.

This monkey is regarded as sacred in Hinduism, and bands of langurs spend a good deal of time roaming at will in villages and temples, sometimes raiding crops and grain stores. They usually live in bands of 20–30.

The social system of alloparenting is widespread amongst this species, where the babies of langurs are often cared for and raised by females other than the mother. Their bodies are long and slender, as are their limbs, hands, feet, and extensive tails. The baby gray langur is almost black when born.

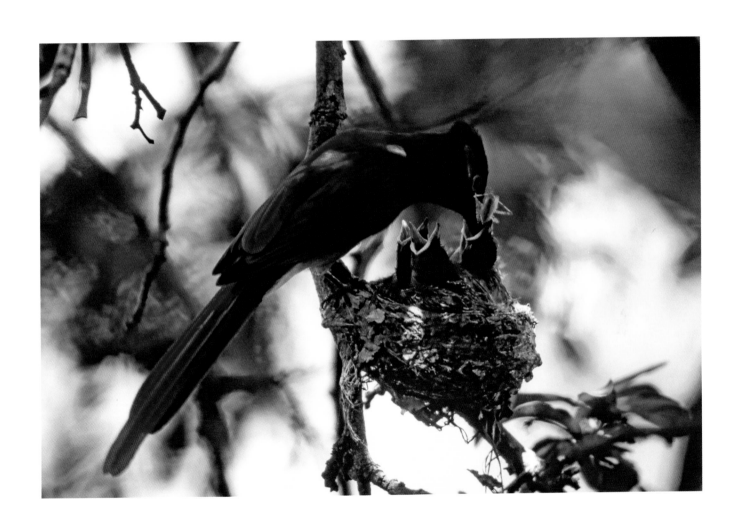

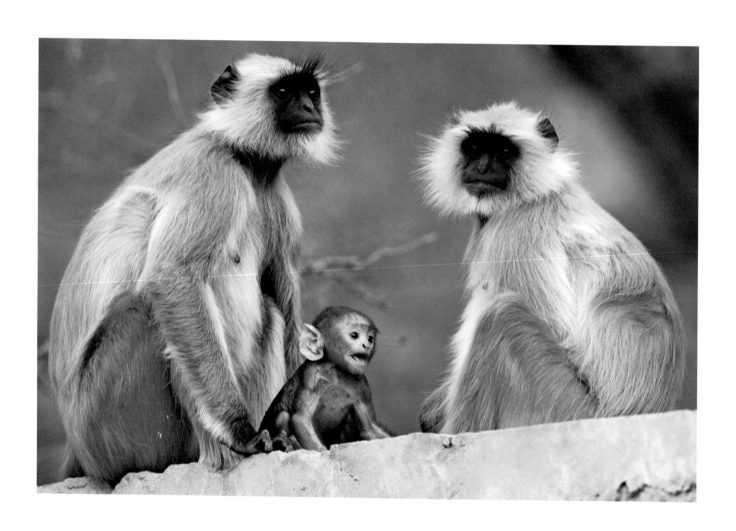

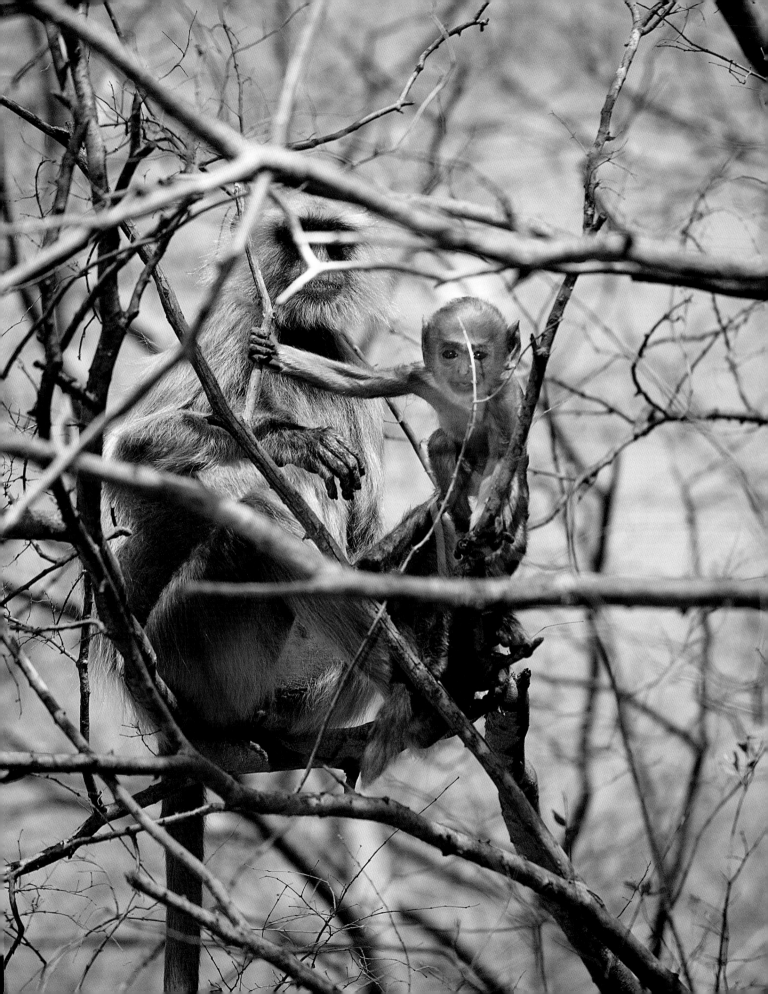

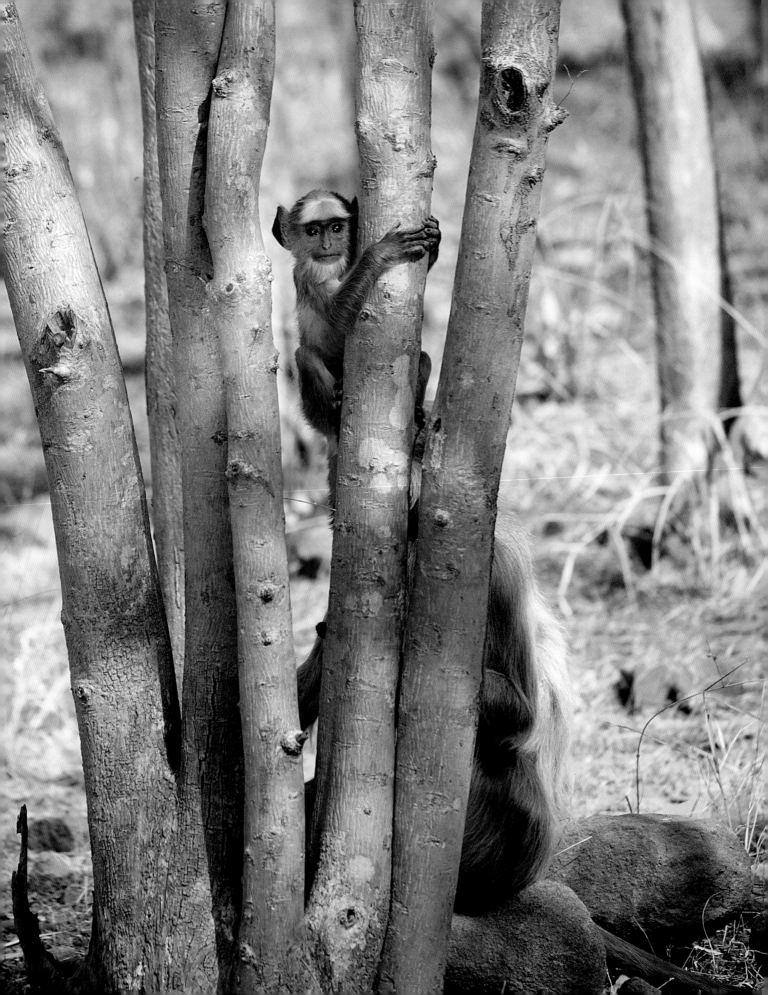

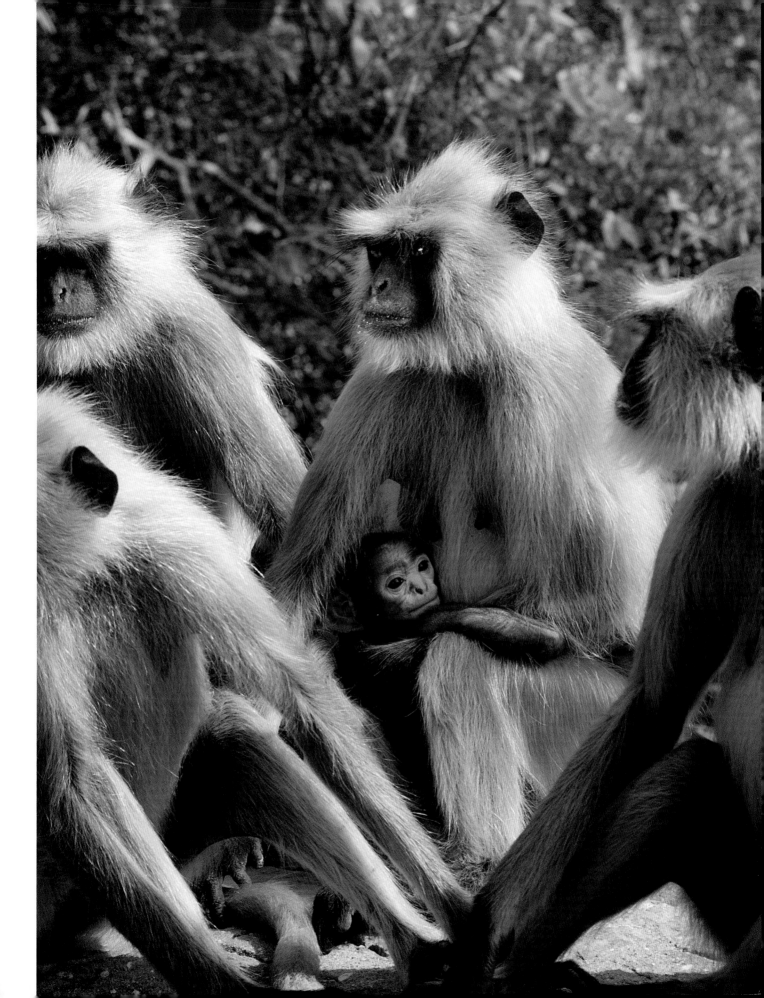

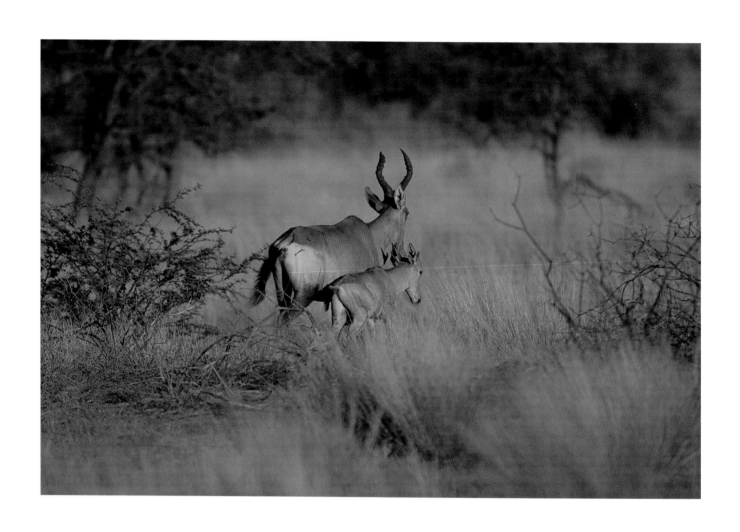

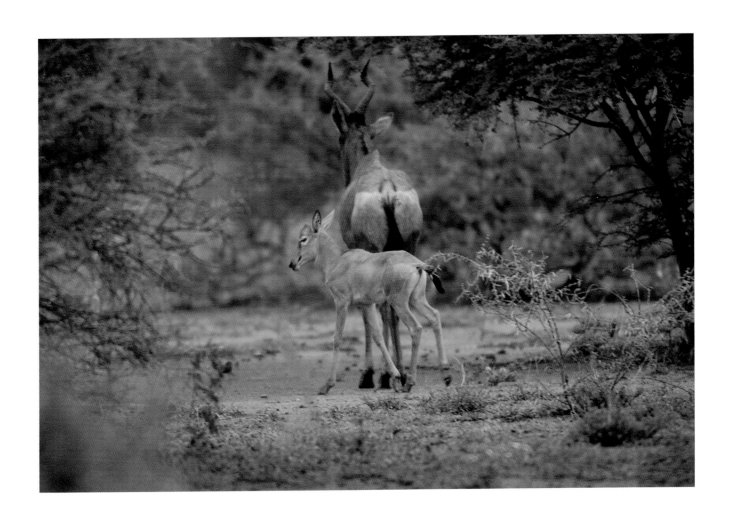

Previous spread, left to right: A red hartebeest *(Alcelaphus buselaphus)* wanders with calf in different parts of the Pilanesberg National Park, South Africa.

The hartebeest has an elongated, somewhat ungainly face, and humped shoulders. Most individuals are a reddish-brown color, though this can vary to a yellow-brown or tawny. Red hartebeest are associated principally with open country and grassland. They usually live in herds of about 20, although in Botswana we have seen larger herds. They avoid dense woodland, and are grazers.

Challenges between rival males often result in savage fights, during which they interlock their curved horns and attempt to force each other down. Hartebeest have a well-developed sense of smell and hearing, but their sight can be poor. When panicked by a predator they tend to mill about uncertainly, snorting loudly, before running off in a zigzag fashion. They are good runners when they reach their stride, and can gain speeds of over 40 mph.

The gestation period is around 8 months, and mothers carrying babies will depart the herd and give birth alone to a single calf usually late in the year. The mother finds a sheltered spot to leave the baby, and visits it to feed and clean it. Once the baby is strong enough it travels with the herd. A mother hartebeest is said to be able to recognise its own young from a distance of 300 yards.

At right: A roe deer *(Capreolus capreolus)* nuzzling its spotted fawn in the forest bracken.

Roe deers have reddish-brown coats in summer and grayish-brown coats in winter. They are prized as game animals for their venison, and though they are not distance runners, they are expert at hiding in thickets. They make a barking sound when alarmed.

For a fawn to survive it must be born in late May, soon after the spring vegetation grows.

The animated film *Bambi* (1942), adapted from the book *Bambi, a Life in the Woods,* popularized the idea of the gentle, beautiful fawn, and it is still a children's classic today.

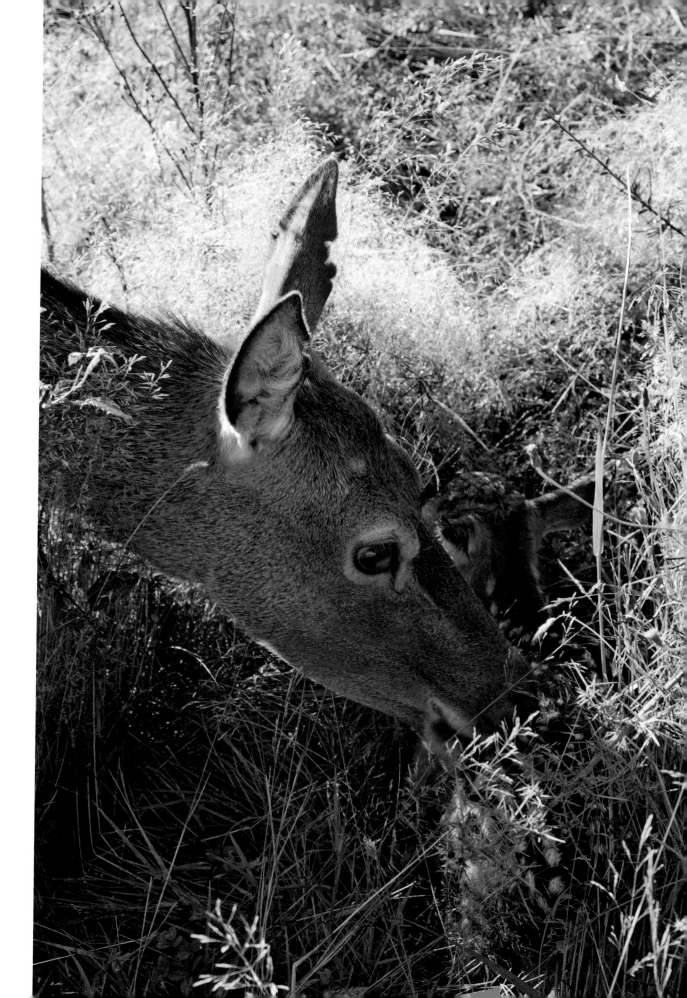

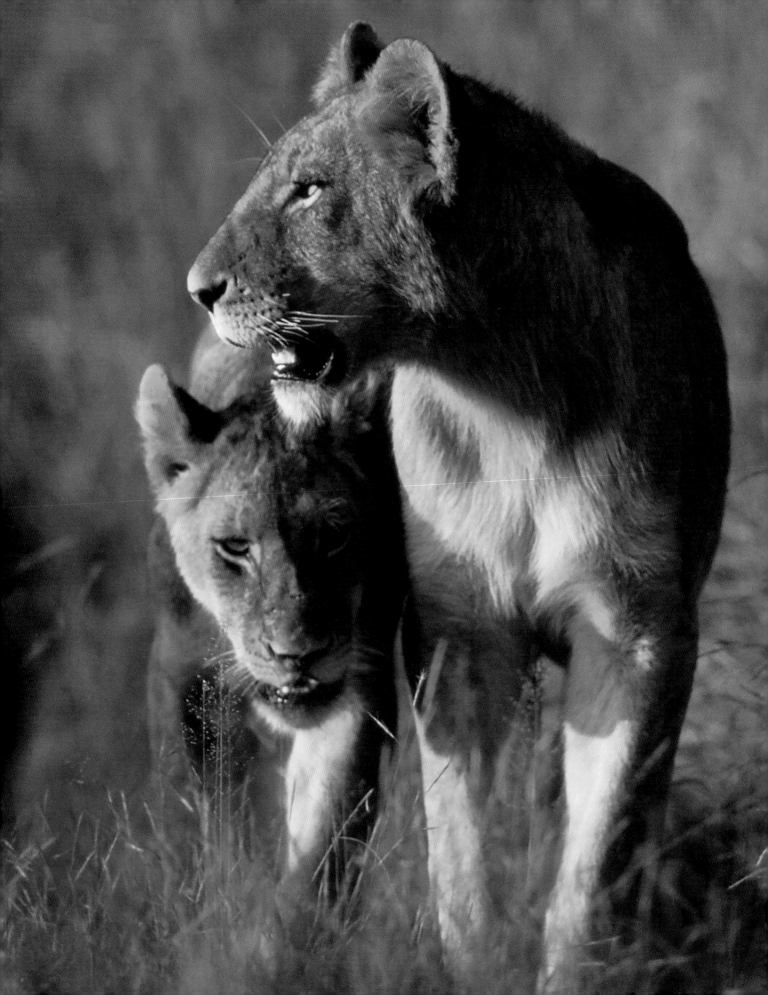

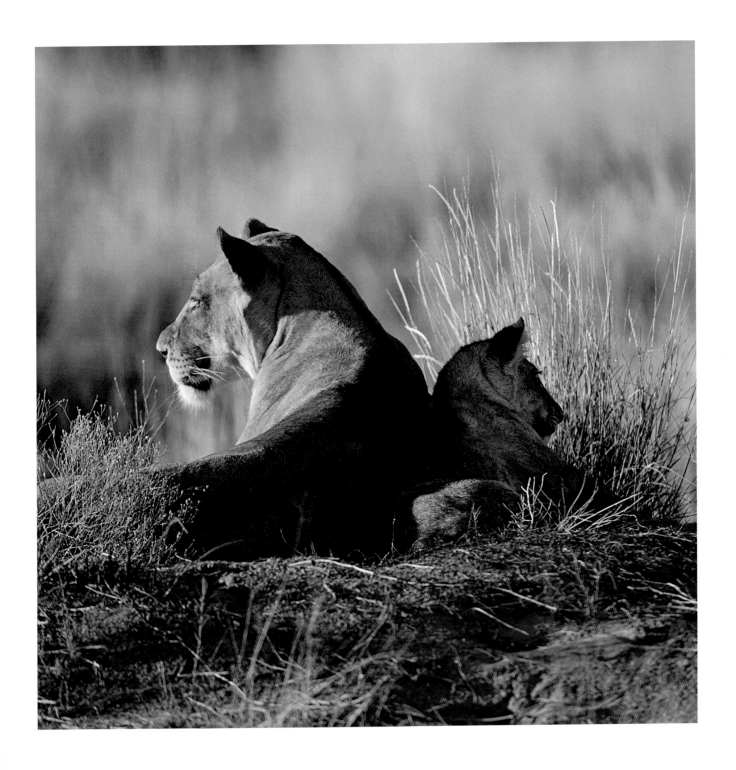

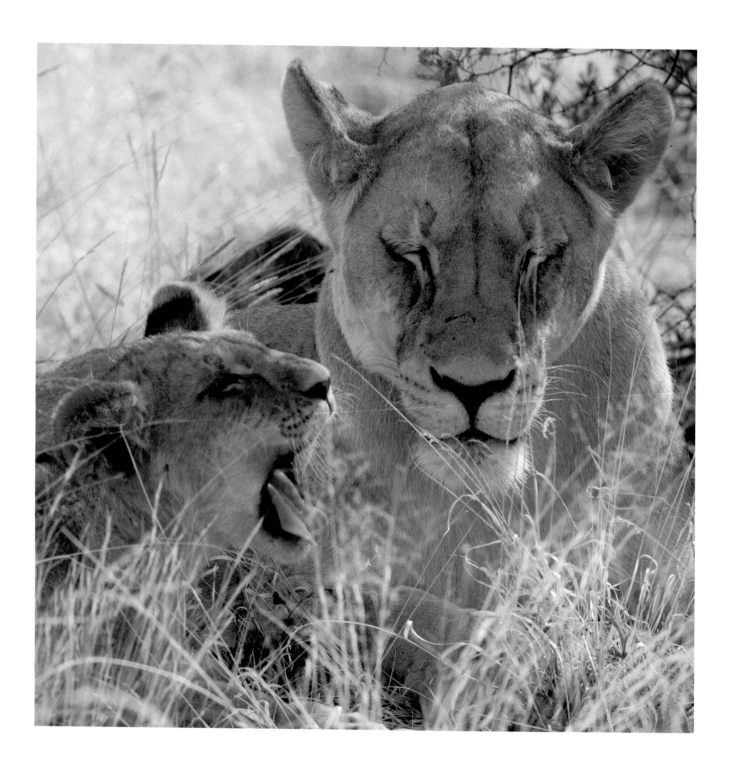

At left, and previous spread: A lioness *(Panthera leo)* with cub in the southern Kalahari Desert. Lions always appeared clean and groomed in the Kalahari—not so in other places.

The lion is a powerfully built, muscular cat, second in size only to the tiger. The lion's mane is the outstanding feature of the male, which can be 6–7 feet long when fully grown. A female is much smaller, usually close to 5 feet. The lion's coat can be a buff-yellow, beige, and even silvery-gray, with a tuft on the end of the tail normally darker in color than the coat.

Females begin to breed around 4 years of age, and carry the baby for approximately 4 months. Females nurture the cubs (the male lion takes little interest in his offspring), which eat what is left when the adults are finished. Male lions are known to commit infanticide.

A group of lions is called a "pride," and the members of a pride usually spend their days in a few scattered groups, often sleeping until the pride unites in the evening to hunt as a team. Each pride keeps to a well-defined domain. More often than not, the female is the hunter. They primarily prey on medium-sized hoofed animals like zebras, antelopes of all kinds, and wildebeests, though they will attack larger animals like buffalo or baboons, as well as smaller animals when the need arises.

Following spread: White-faced saki *(Pithecia pithecia)* and delightful offspring.

These tiny arboreal South American monkeys grow to only 12–20 inches long. Females weigh around 4 lbs, and males a little more. They are diurnal, and have been known to leap long distances for their size, being recorded as able to cross spaces of 30 yards.

Sakis live in monogamy, and births are single. Babies are carried by the mother for a time, until they can move independently. Sakis are nervous and difficult to keep in captivity.

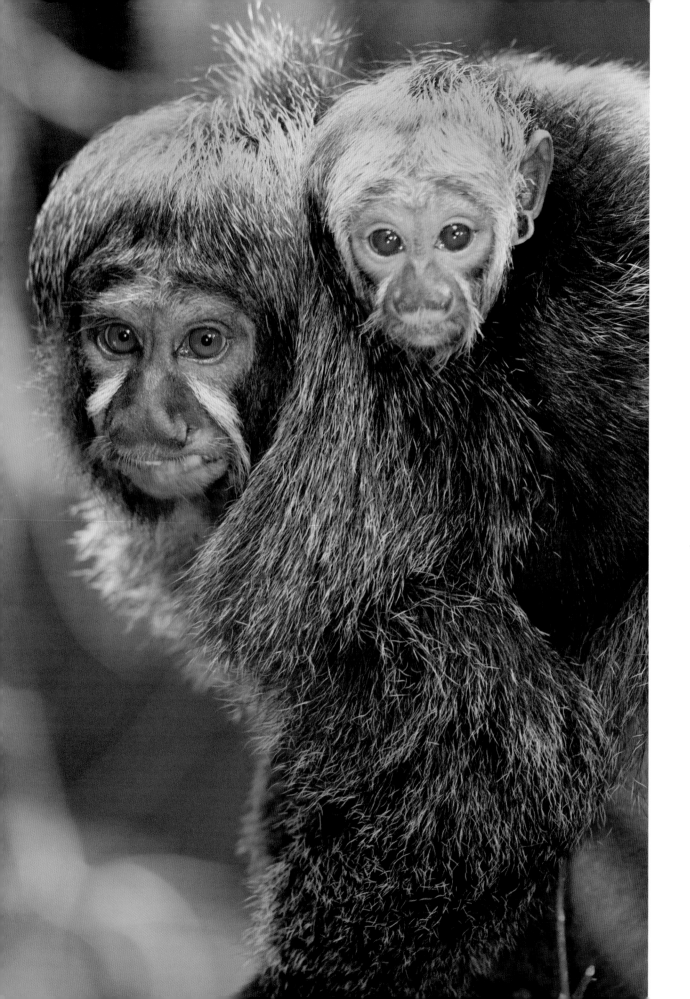

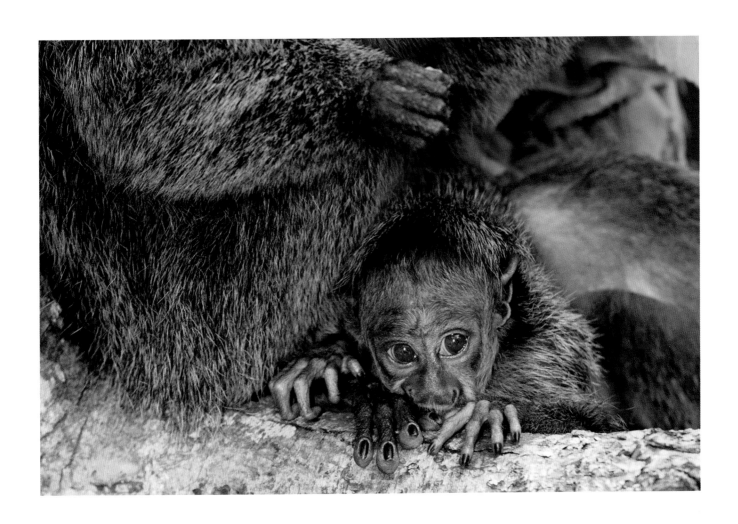

At right: A brown bear (Ursus arctos) and its cubs at the forest's edge on Kodiak Island, Alaska, USA.

The brown bear is a shaggy-haired species frequently referred to as a "grizzly" in North America (Canada and USA). They are omnivorous, like humans, and feed on fish, plants, roots, berries, rodents, small mammals, and a variety of other foods.

Brown bears have a wide geographical distribution; there are about 200,000 of them worldwide, and are native to north-western North America, Europe, and Asia.

Bears accumulate a large amount of fat during late summer and autumn, and retire to their dens in winter. There, they hibernate, and amazingly the female brown bear is able to give birth and nurse her cubs during this process—though the cost to her is high, as she loses up to 40% of her body weight. Cubs, usually twins, weigh less than 2 lbs at birth.

Following spreads: An orangutan *(Pongo sp.)* mother and her baby enjoy their bond, and the mother transports her baby on high.

The orangutan, which translates to "person of the the forest" from the Malay and Indonesian, is the largest arboreal animal in the world. The species is long-lived, and females don't reproduce until after 15 years. The rate of birth for orangutans is the slowest in the mammal world, with intervals of around 8 years between babies. This makes an orangutan baby very special and appreciated.

These primates are closely related to humans, with only the chimpanzee and the bonobo having more DNA in common. They are found in the lowland forests of Borneo and Sumatra, and consume many and varied foods, though in the main they are ripe-fruit eaters.

Older males develop a unique feature in wide cheek pads, and some males have such long hair that it can look like a cape on their backs. Another unusual feature is that orangutans use vegetation to protect themselves from rain, and almost every night they construct a sleeping platform up in the trees, from branches, twigs, and leaves.

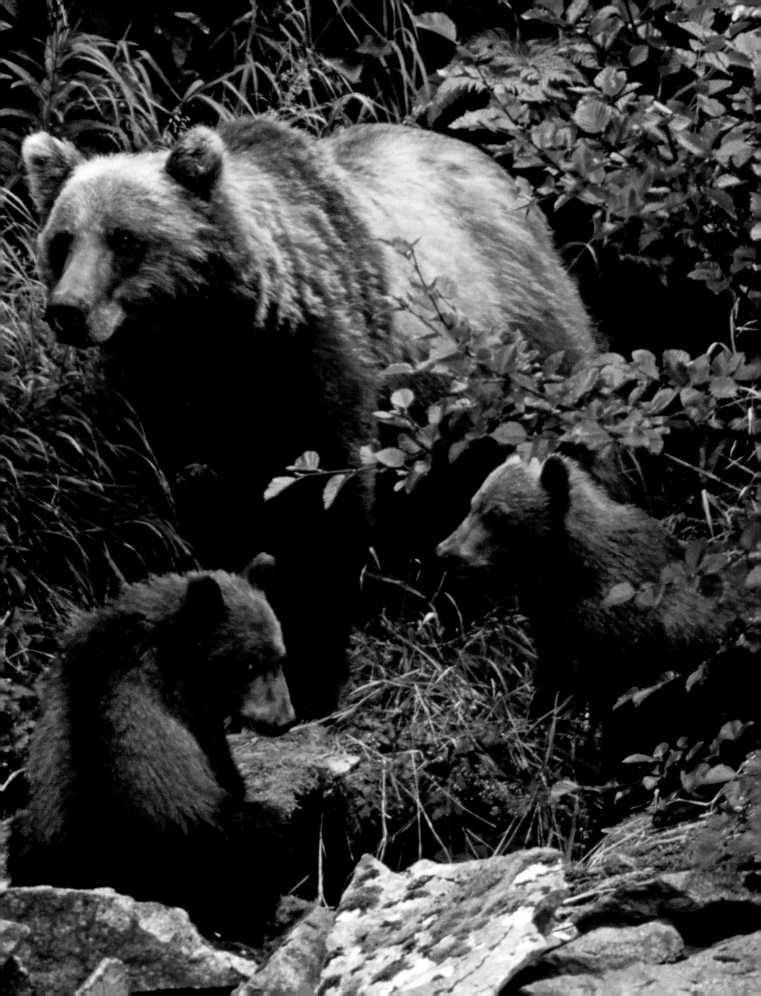

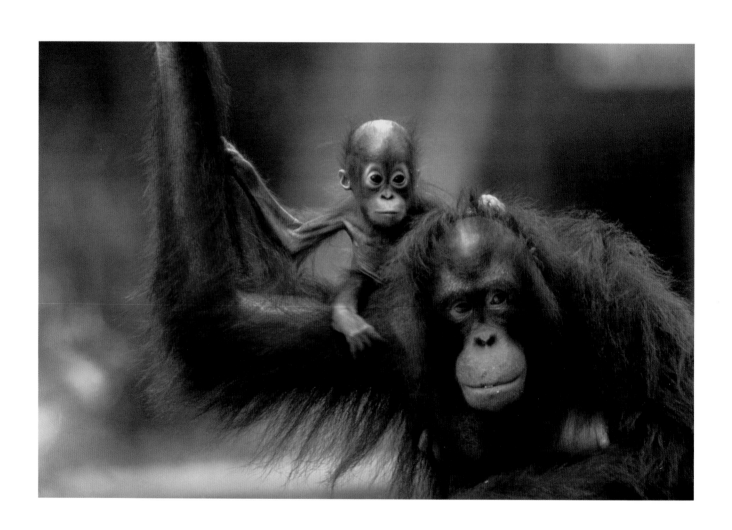

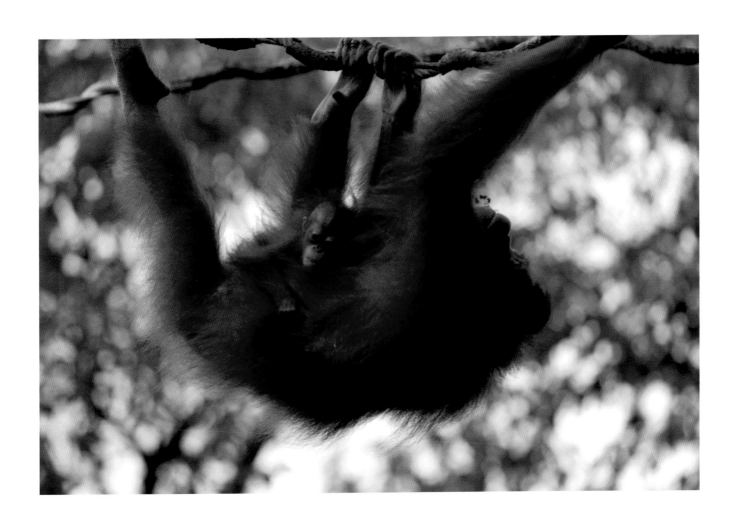

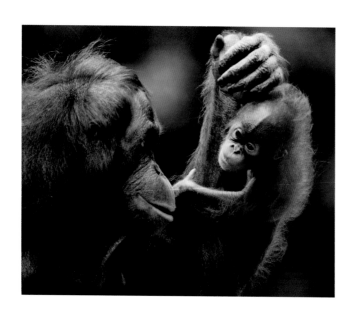 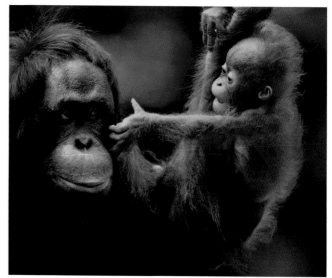

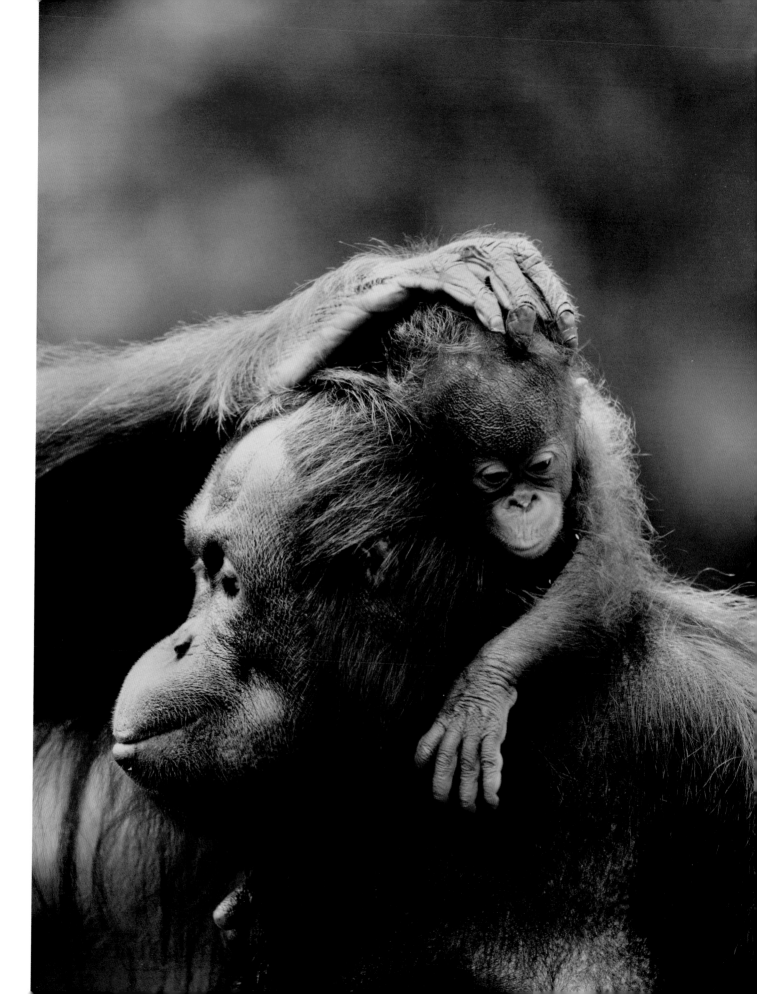

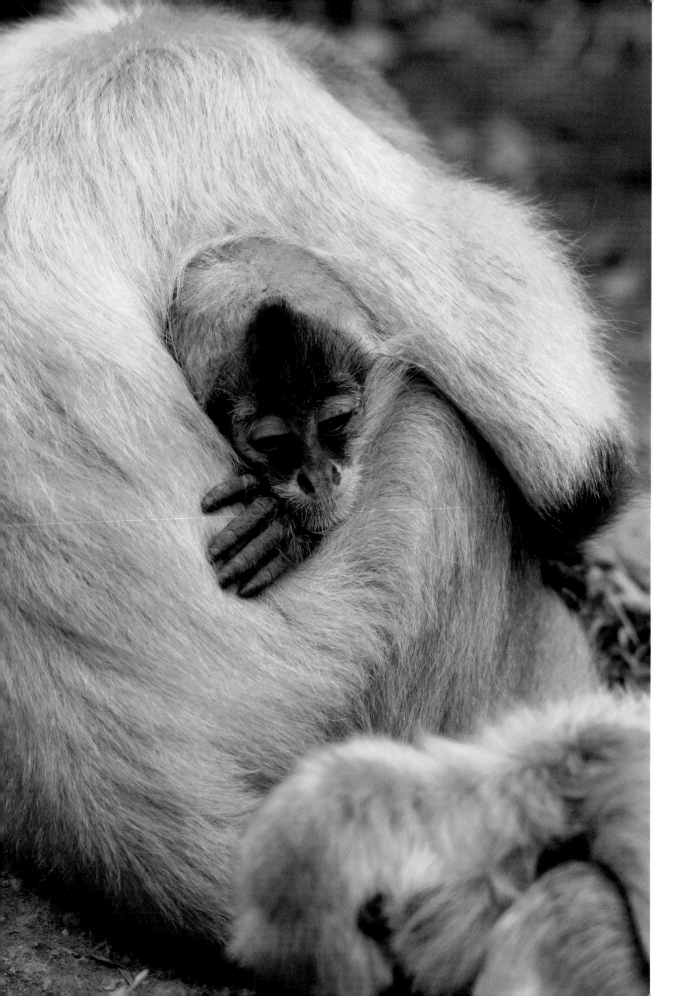

At left: A spider monkey *(Ateles sp.)* baby nestles peacefully under its mother's arm. This large, agile monkey lives in forests from southern Mexico south through Central America to Brazil.

In spite of not having a thumb, this lanky primate can move at speed through the trees using its prehensile tail like a fifth limb. They hang from branches using their tails, and can pick up objects with them as well.

Spider monkeys weigh about 13 lbs, and are 14–26 inches in length excluding the tail. Most have black faces with white eye rings. They live in bands of 20–30 and forage in smaller groups, relishing fruit, nuts, seeds, flowers, and leaves, as well as spiders, and birds' eggs.

It appears that all true spider monkey species are threatened, and most are endangered. This is because of hunting and loss of habitat through logging and forest clearing.

A single baby is born after the mother carries the child for 4–5 months. The baby is dependent on the mother for at least a year.

Previous spread, left to right: Across the wide, lonely tundra west of Hudson Bay in Manitoba, Canada, a mother polar bear *(Ursus maritimus)* treks with her two offspring before finding a spot in the snow in sunshine to halt and show affection.

This great white northern bear is found throughout the Arctic region. With its unusually potent sense of smell, it can detect prey over half a mile away, and up to a yard under the snow. It can find young seals, its favorite prey, in snow shelters where they were born. The polar bear will travel across desolate, drifting oceanic ice floes for immense distances in search of seals. It shows no fear of humans and has no natural predators, which makes it a very dangerous animal.

Polar bears are large and solid, with lengthy necks, relatively small ears, and black snouts. Solitary and strictly carnivorous, they are excellent swimmers, and have occasionally been known to kill beluga whales. The babies, up to 4, are born in the winter in a den of ice and snow. The baby weighs less than 2 lbs at birth, and is not weaned until it is 2. Polar bear mothers are extremely defensive of their young.

At right: An alert mother Sable antelope *(Hippotragus niger)* with calves on the South African veldt, in Kruger National Park.

Sable bulls are handsome, large animals defined by glossy black coats accented with white underparts. Females and young, as shown here, are chestnut and even sandy-colored. Both sexes have stiff, comb-like manes, and grow long, ridged horns which curve backwards. These horns are an effective defensive weapon, used in fights over dominance. They can grow to an impressive yard long, and sable antelopes will defend themselves fiercely with their horns when necessary, yet this imposing feature also makes them vulnerable to trophy hunters.

Their diet consists mainly of grass. They are sociable and territorial antelopes, and herds of up to 70 (even larger in Zimbabwe) roam ranges of 4–19 square miles. Young males are driven off by the older males and form bachelor herds until they mature at 5 years and compete for territory. Females can conceive at 2 years and calve after 9 months.

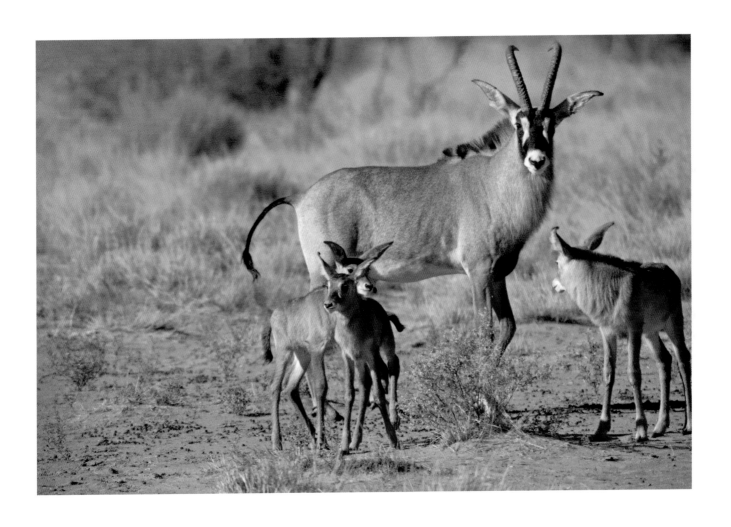

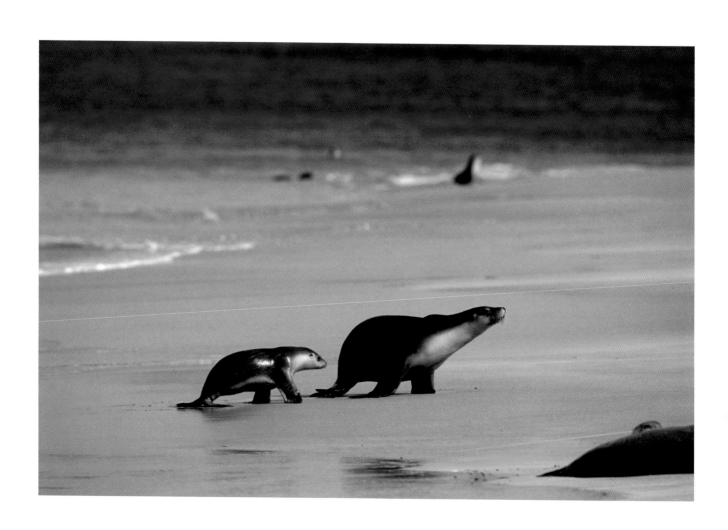

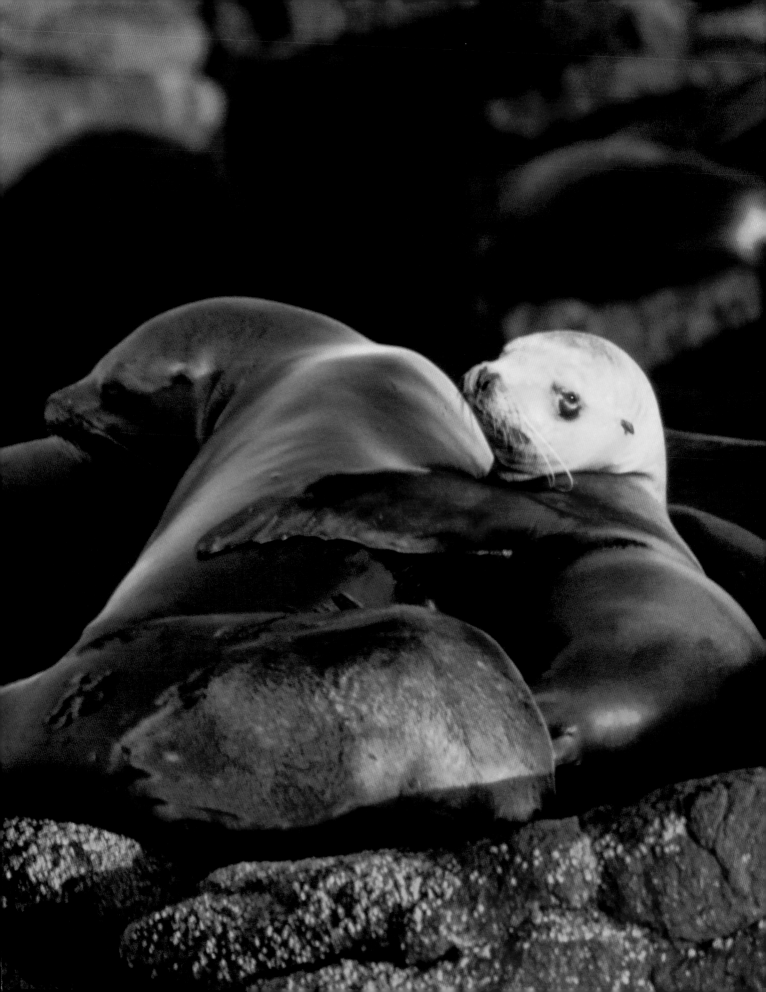

Previous spread, left to right: A sea lion *(Zalophus sp.)* leads its baby across the beach on Kangaroo Island, Australia; sea lion mother with pup rest in the golden light of afternoon on the Island of Islotes, in the Gulf of California, Mexico.

Sea lions are a species of "eared" seals and are found mainly in Pacific Ocean areas. For protection against predators, they will stay close together on land and in water. They can rotate their hind flippers forward, unlike earless seals, and thus can use all four limbs when moving about on land. They also have longer flippers than real seals.

They eat mainly sea creatures like fish, squid, and octopus but at times have been known to have consumed penguins.

Males can reach a length of 8 feet and establish large harems of up to 20 females. Cute brown pups are born after a long gestation period of 12 months.

Large-eyed and playful, they are fast swimmers and exceptional divers. They can forage under water for three minutes at a time, and they frequently leap from the water when swimming.

At right: Little terns *(Sterna albifrons)* with a cute speckled chick on Barrier Reef island beach, Queensland, Australia.

Terns are slender, elegant water birds of the family that includes gulls. They inhabit sea coasts and inland waterways, and are distributed worldwide. Many terns are long-distance migrants, the most notable being the Arctic tern. This extraordinary little bird breeds in the southern Arctic, and winters in Antarctic regions, thus making the longest migration of any bird; therefore it also has the distinction of seeing more sunlight than any other animal.

While they will occasionally eat insects, their main diet consists of crustaceans and small fish. Their feet are webbed, and they have long, pointed wings, forked tails, and pointed beaks.

Two or three eggs make up a normal clutch for terns, and usually they breed in colonies on the ground on islands. The chicks are speckled with a white breast.

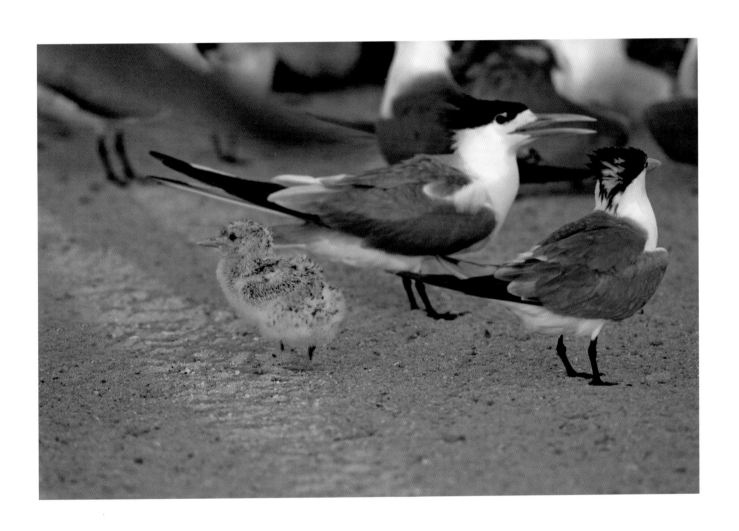

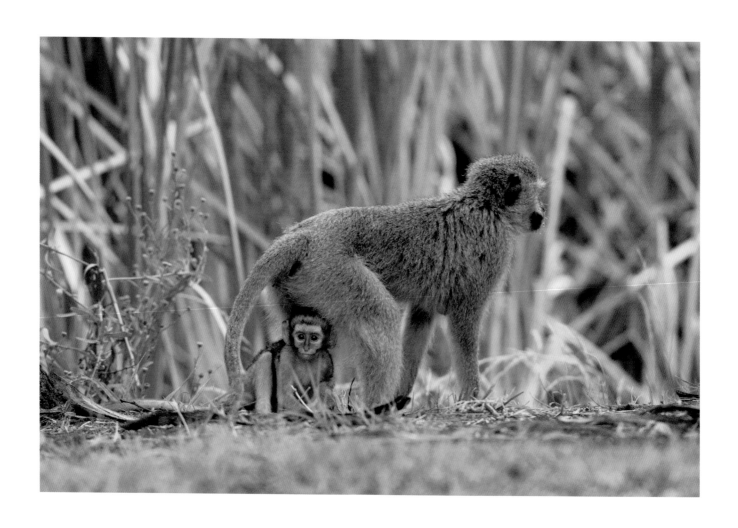

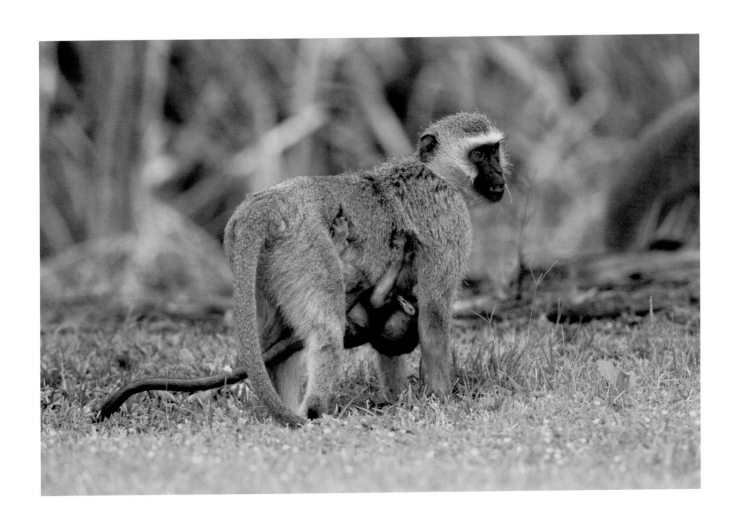

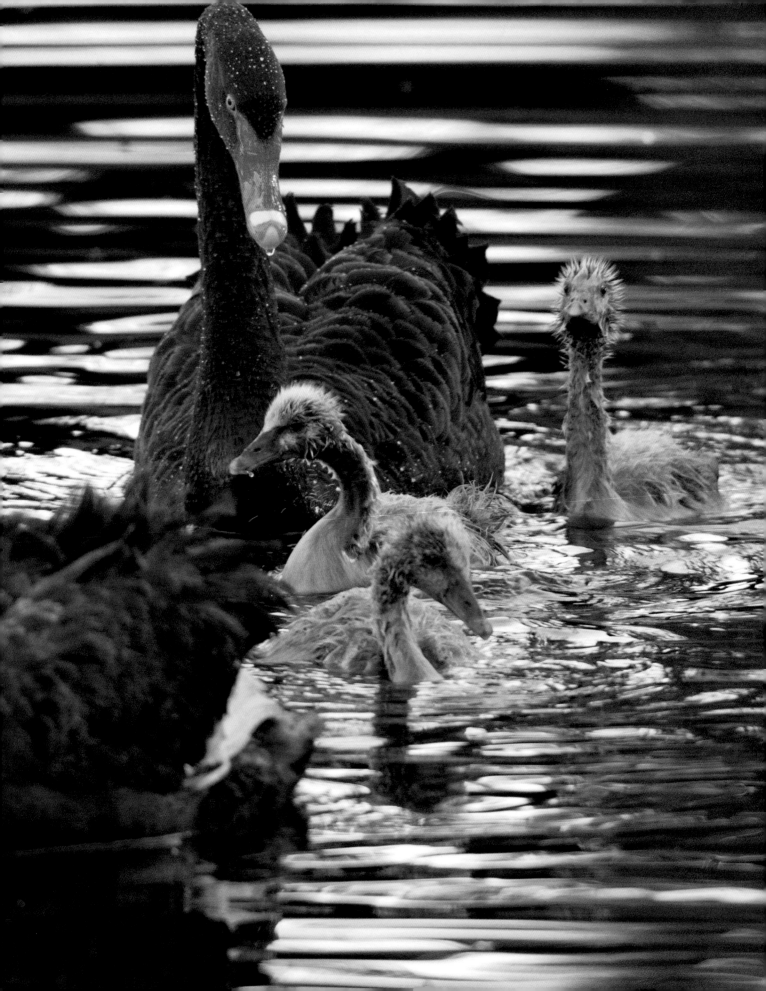

Previous spread: A vervet monkey, or savannah monkey *(Chlorocebus aethiops)*, and its baby play in the Okavango Delta, Botswana.

This endearing, black-faced quadrupedal creature is found from sub-Saharan Africa all the way down to South Africa.

The vervet is relatively small, growing to a size of 18 to 26 inches, and grooming is important. Vervets (along with other monkeys) spend several hours every day removing parasites, dirt, and foreign matter from one another's fur. Their mainly vegetarian diet is supplemented with insects, grubs, eggs, and even sometimes baby birds and rodents. They are not avid water drinkers.

They live in troops of around 10–50 animals, and within the troop every grown female is the center of a small family network. The female vervet gives birth to one baby after a period of 5.5 months' gestation. The baby clings beneath the mother's stomach as she moves along.

At left: A black swan *(Cygnus atrata)* and recently hatched cygnets on a lake in the Southern Highlands of New South Wales, Australia.

Swans are graceful, long-necked, heavy-bodied birds that glide majestically over the water when swimming and make an intriguing vision when they fly, with slow wing beats and outstretched necks. Swans feed by dabbling in shallows for aquatic plants (as opposed to diving).

Courtship involves mutual bill dipping and head posturing. Swans, black or white, mate for life. Both male and female build the nest together, and it is placed on the ground or floats on water. The female, or "pen," incubates about 6 pale eggs, and the male, or "cob," guards her. If the cob repulses an enemy, he will utter a triumphant call. When hatched the cygnets are scrawny with sparse feathers, and the tale of the "ugly duckling" that grew into a beautiful swan is well known. For at least 6 months cygnets are closely watched over by their parents, who are ferocious in defending them.

Swans mature in 3–4 years, live to around 20 years in the wild, and can live to 50 in captivity.

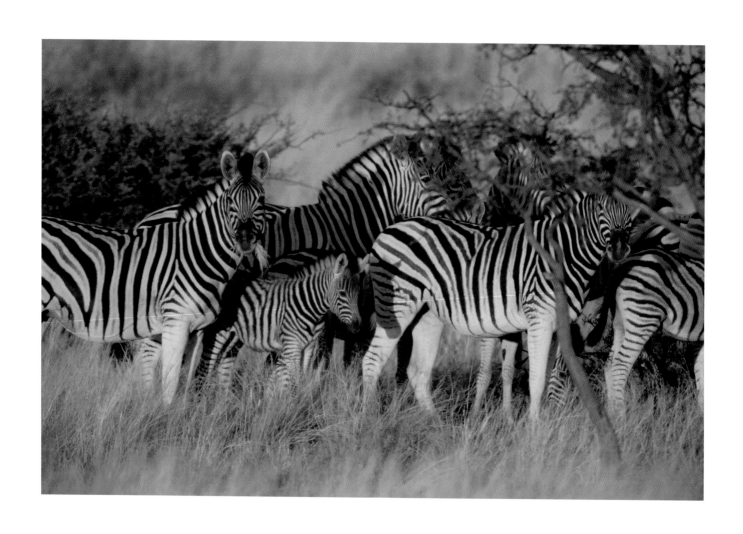

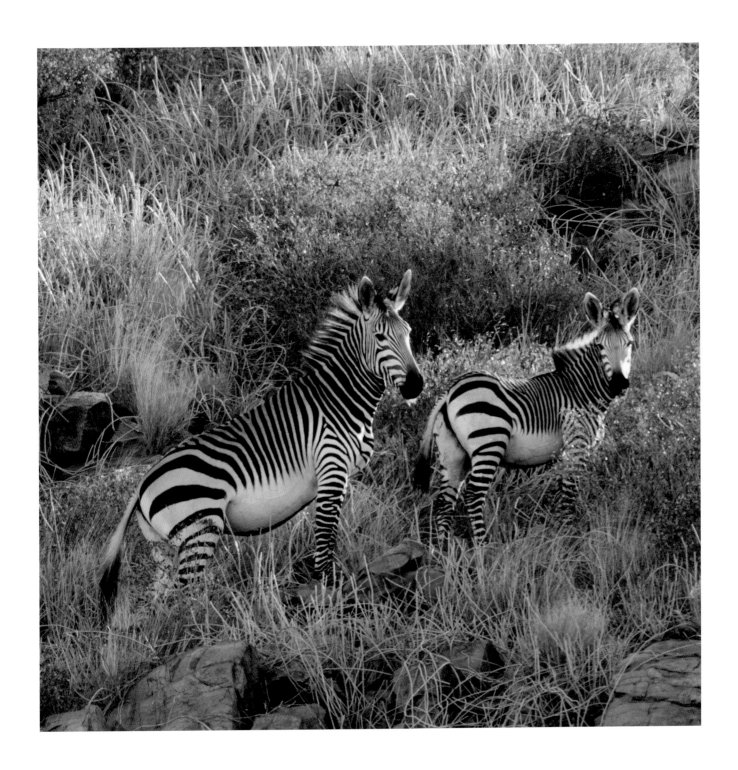

These impressive black-and-white-striped animals are mammals of the horse family: large, single-hoofed ungulates built for speed and long-distance migrations. They can run up to a speed of 35 mph.

Zebras possess strong upper and lower incisor teeth for cropping grass, and large, high-crowned teeth for chewing silicate-rich grasses, which wear down molars.

They have a powerful kick, which they utilize with enemies, and the leading male of a herd, called a stallion as horses are, will sound the alarm if danger is spotted.

In all zebras, their stripes are like fingerprints, which enable identification of a single individual.

Gestation for the zebra mother takes place over 12–13 months, and a single baby is born.

These breeding places for gannets can hold thousands of birds and their blue, chalky eggs. The hatchlings are fluffy and completely white, and almost as large as their mothers.

Courtship for gannets involves preening, bowing, and head bobbing. The nests are tightly packed into the gannetry, and a bird that lands in the wrong place can be attacked.

The Australasian gannet is found in New Zealand and Australia, and is easily identified, with its wide wingspan, golden head, and dramatic plunging dives. Each year more white feathers appear on the backs of the birds, and they acquire their adult appearance in 5 years.

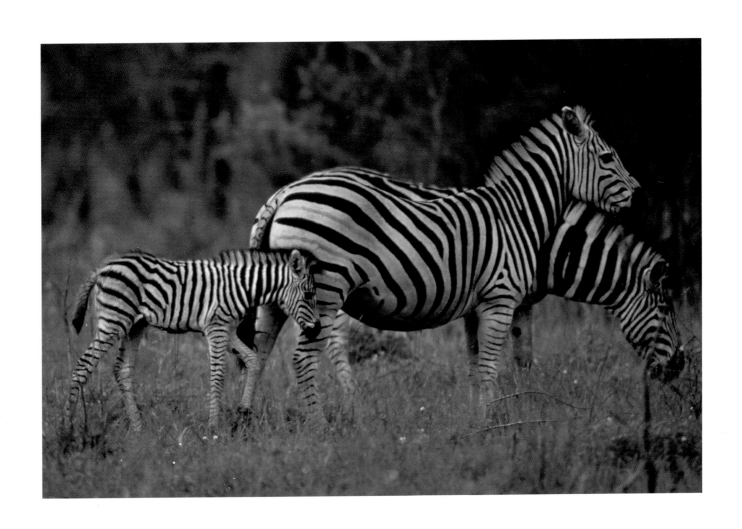

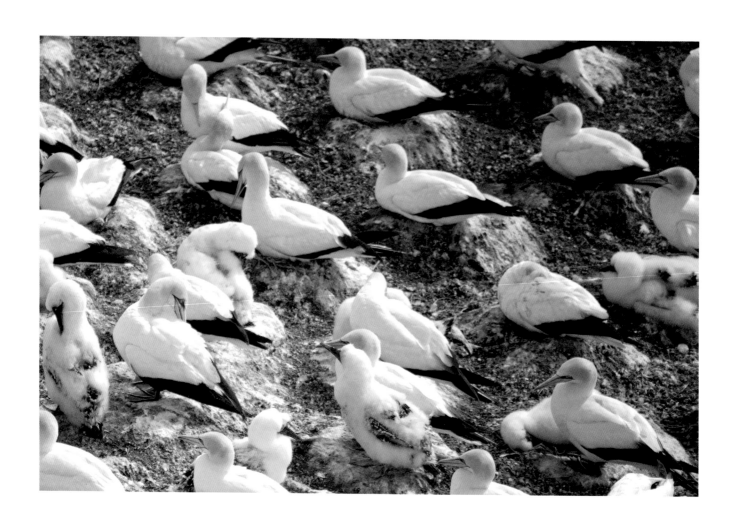

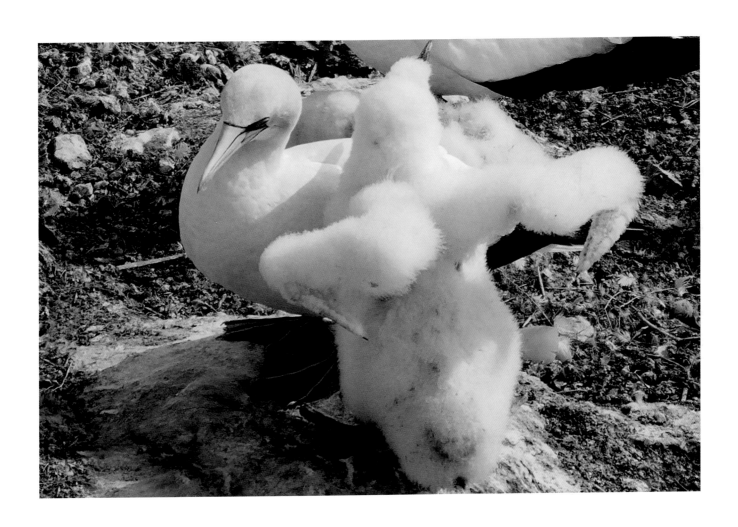

At right: An ebony langur *(Trachypithecus auratus),* with the sun bestowing a halo in its bright colored hair, holds its sweet sloe-eyed baby closely in its arms. This individual and its baby are of a rare subspecies, and are a glorious deep orange color with yellow tinges around the ears.

The ebony langur is an endangered species that has a relatively large, complex stomach adapted to a diet of fruit, leaves, and vegetation. The word langur means "long tail" in Hindi, and this langur, which is native to the island of Java in Indonesia, has the long tail and slender body of all langurs, reaching a length of approximately 3 feet. The adult weighs about 15 lbs. Like other langurs, this animal is basically arboreal and diurnal.

Following two page spread: An African elephant (Loxodonta africana) keeps its newborn calf close in grassland near the Chobe River, Botswana; a baby on the move with its mother in Kruger National Park, South Africa and an African elephant calf nuzzles its mother.

Elephant calves are born after an extensive gestation period of 2 years. The baby remains dependent on the mother for several years, and the calf is cared for by other females in the herd.

The elephant is the largest living land animal in the world, standing 10–13 feet at the shoulder. It has sparse body hair, its skin is wrinkled, and it is usually grayish to brown in color.

The trunk, or proboscis, of the elephant is a versatile organ. It is a combination of the nose and the upper lip, and nostrils are located at the tip. The trunk is large and powerful, and elephants are able to lift loads of up to 500 lbs. It is dexterous, sensitive, and mobile, and comprises 16 muscles. At the tip of the trunk are flap-like projections that enable the animal to perform amazingly delicate functions. Elephants use this wonderful organ like a hand.

Elephants make a trumpeting sound when roused, and have a wide range of calls for different purposes. An elephant can recognize other elephant calls from half a mile away. Researchers have found that females have the most extensive repertoire of calls (70% of calls are made by females and juveniles, and only 30% by males). Any reunion of elephants is met with an exuberant greeting.

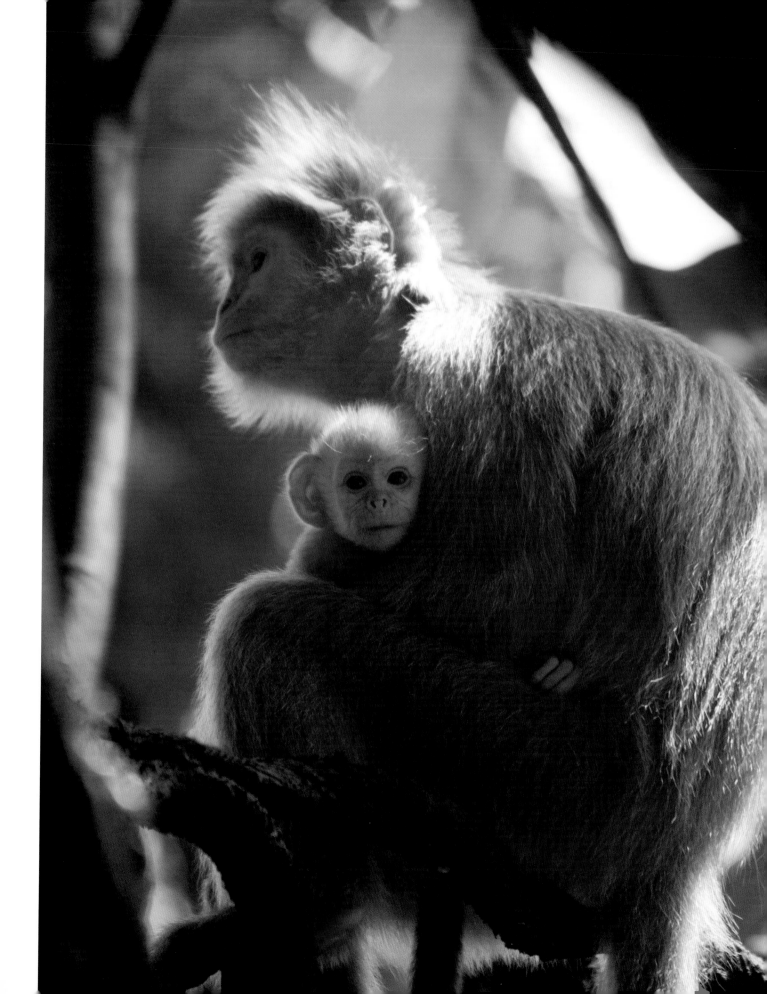

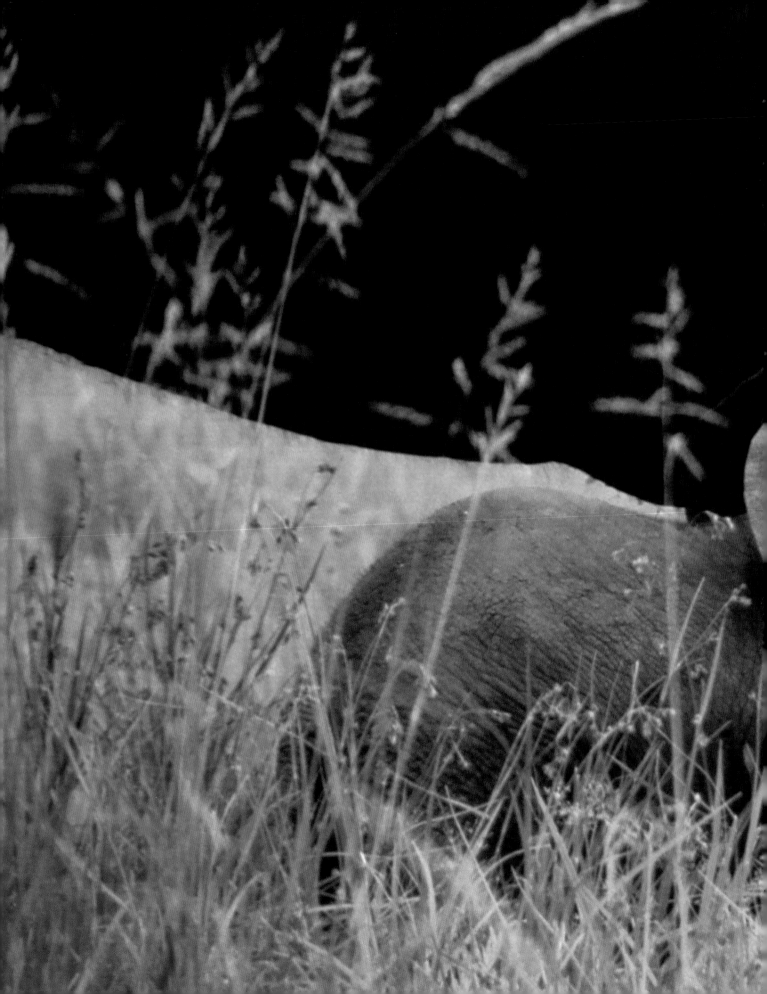

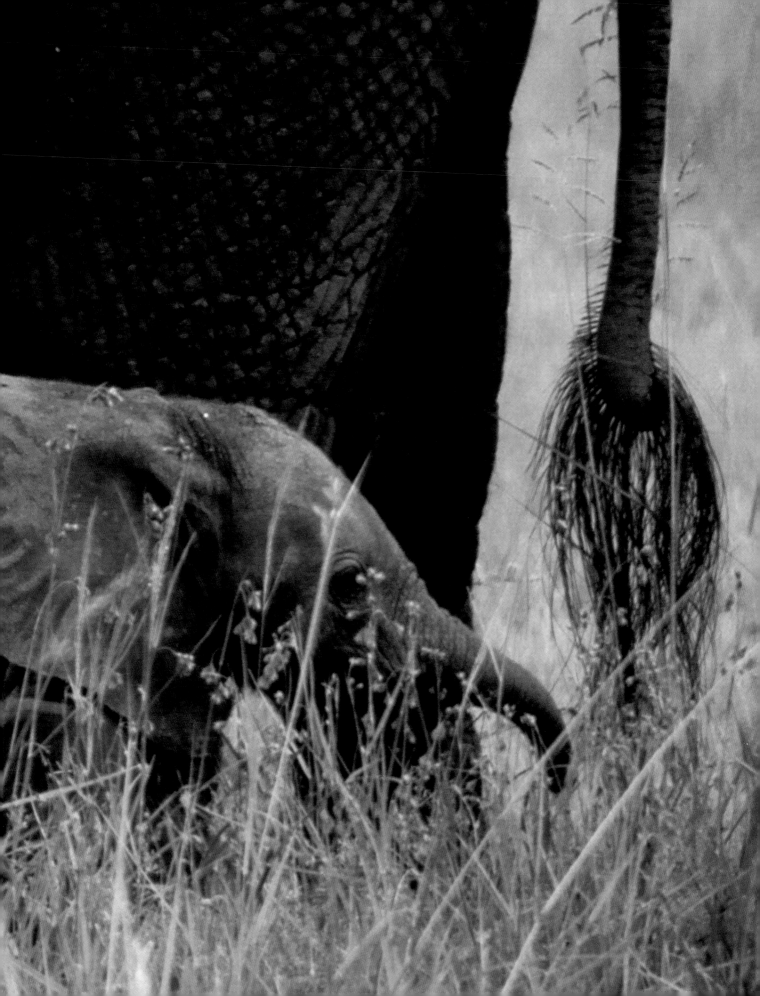

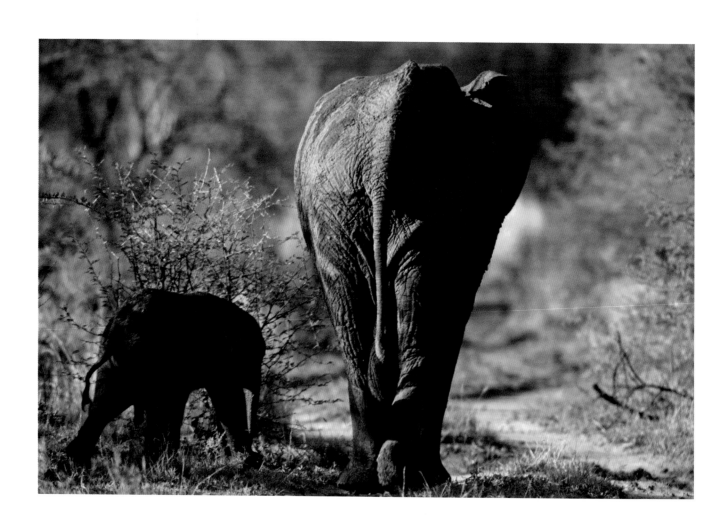

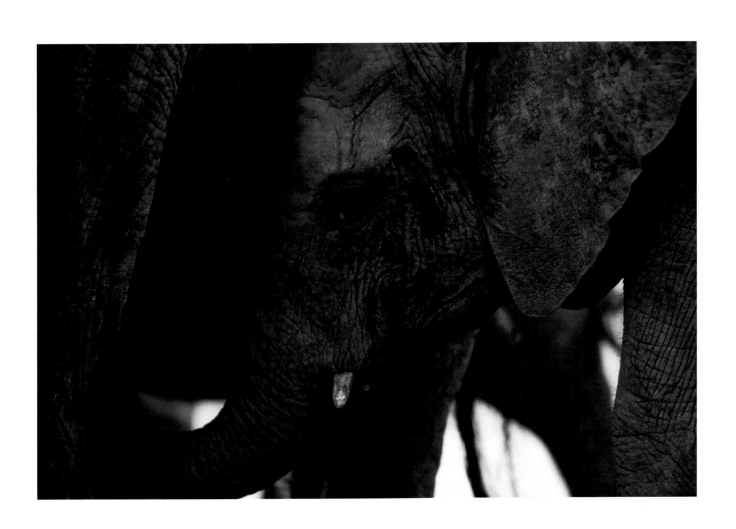

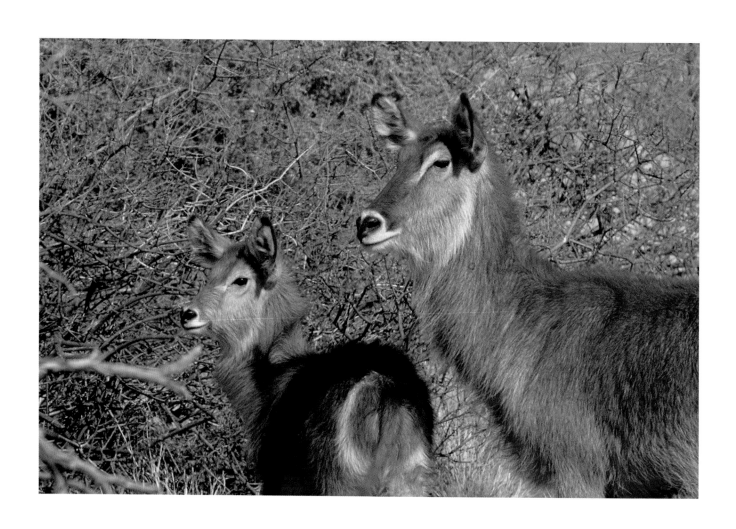

At left: A gentle-faced waterbuck antelope *(Kobus ellipsiprymnus)* and its calf stand warily in scrub in Kruger National Park, South Africa.

As its name suggests, this mammal is often found near, or in, water, which it is dependent upon. Waterbucks have coats that are shaggy and a brownish-gray, while they usually have eyes and noses patched with white. The rump of this animal has a characteristic white ring, and only the bulls have long, forward-curving horns.

Gestation is around eight months, and usually a single calf is born, though twins are not unknown. The newborn is hidden in scrub, dense bush, or long grass before it is able to join the herd. The male can grow to a weight of 500 lbs and more, and the female is always smaller.

Following spread: A brown booby *(Sula leucogaster)* and its baby chick sit in the nest, illuminated by a shaft of sunlight on the small island north of Anguilla called Hat, or Sombrero, Island. The island is home to colonies of boobies and their chicks, along with various other seabirds that breed there because it is free of predators.

The brown booby is a tropical seabird with a brown head and upper body feathers and contrasting white elsewhere. It has a pointed tail and long, narrow, pointed wings. There are about six different species of booby, which are normally 1 to 2 feet in length. They fly high above the ocean searching for schools of fish and squid on which to feed, and when they see prey they plunge headlong into the sea in a swift and almost vertical drop.

During courtship the booby male performs a ritual dance that includes a long, continuous whistle. The female usually incubates two eggs, and the species nests in colonies, although they retain a highly developed sense of their own territory and will defend their own nest area with defensive displays like beak jabbing and head nodding. In many cases the second chick to hatch will be pushed out of the nest by the first, who is stronger—Darwin's theory at work.

Boobies are not afraid of humans, and this made them easy targets for early exploring mariners.

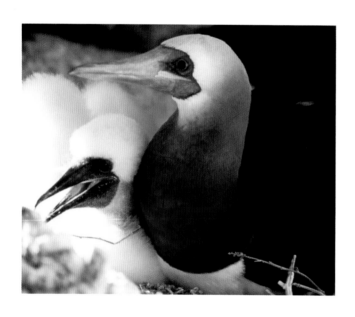

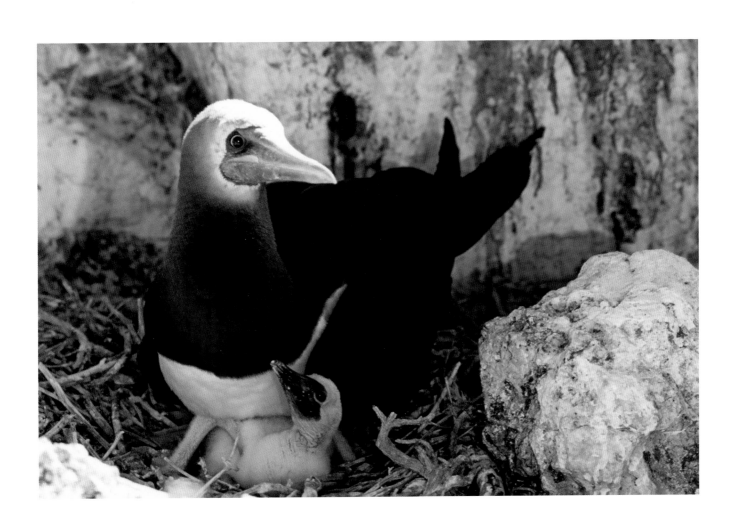

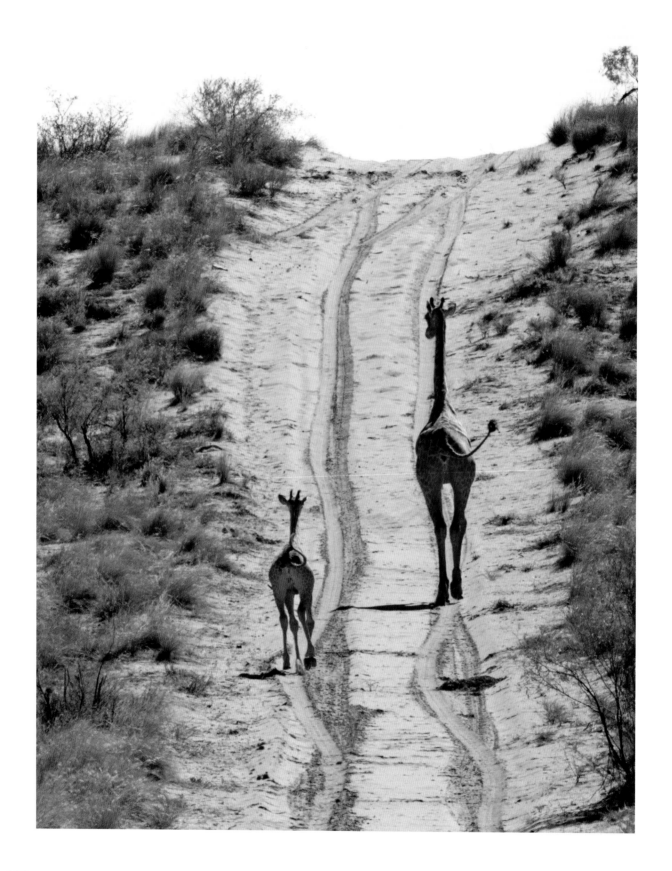

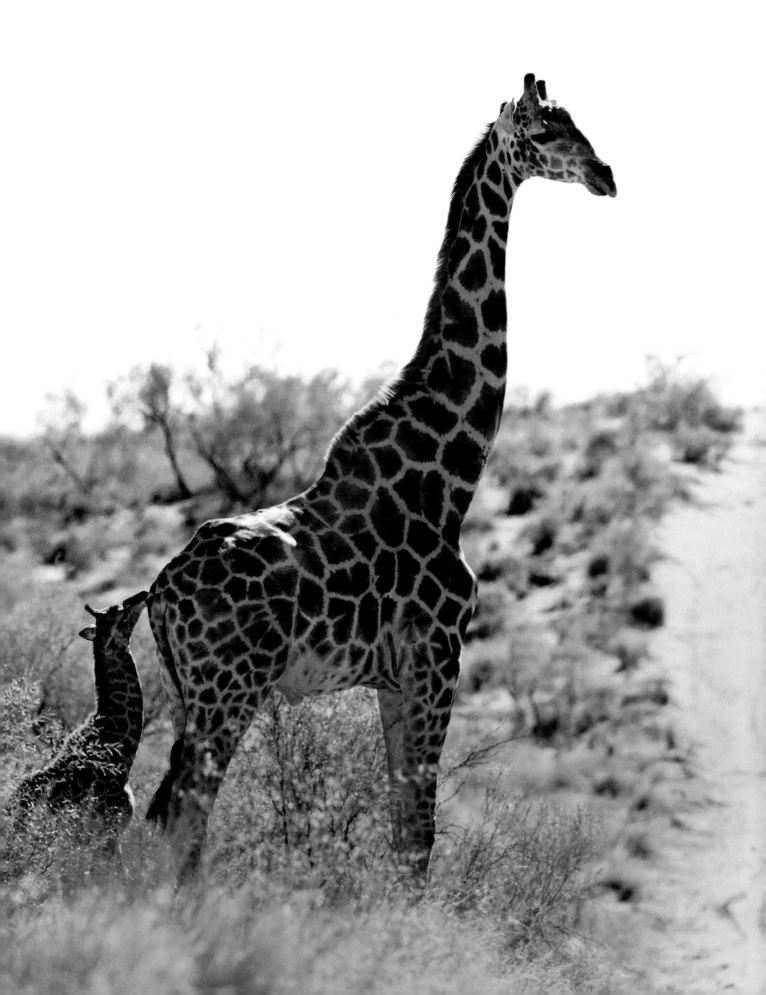

Previous spread, left to right: A mother giraffe *(Giraffa camelopardalis)* and her baby wander up a dirt track in the southern Kalahari Desert in the Northern Cape, South Africa; at the side of a track in the southern Kalahari Desert, a young giraffe approaches an adult male. *At right:* A mother giraffe and baby on the veldt in Kruger National Park, South Africa.

A newly born giraffe is sometimes 6 feet tall, and can weigh nearly 150 lbs. After carrying the baby giraffe for 15 months, a mother gives birth to the babies in a standing position.

They grow to their full height by 4 years of age, but continue to gain weight until they are 7 or 8. Males can weigh a massive 4,250 lbs, close to 2 tons, and can stand more than 18 feet tall. Grown females weigh a little over half the male weight.

Giraffes' tails are over a yard long, and both sexes have a pair of small horns. They utilize a prehensile tongue that is around 18 inches long, and can browse foliage higher than any other land-bound animal. They prefer to eat new shoots and leaves.

Giraffes can live up to 26 years in the wild.

Following spread: A lion-tailed macaque *(Macaca silenus)* mother high in a tree with its attractive little one.

The bodies of lion-tailed macaques are black, and the name refers to the long, thin, lion-like tail, with its tuft of fur on the end, though it also has a type of full-bunching ruff, or mane, around the face.

Lion-tailed macaques, which are found only in parts of southern India, are small: the male is between 16 and 28 inches long and the female is smaller. They live in groups and are active during the day. The majority of their time is spent in the trees, and they are cautious if they come to the ground. They have been known to be trained to pick coconuts.

After 5–6 months they give birth to a single offspring, which weighs about 1 lb at birth.

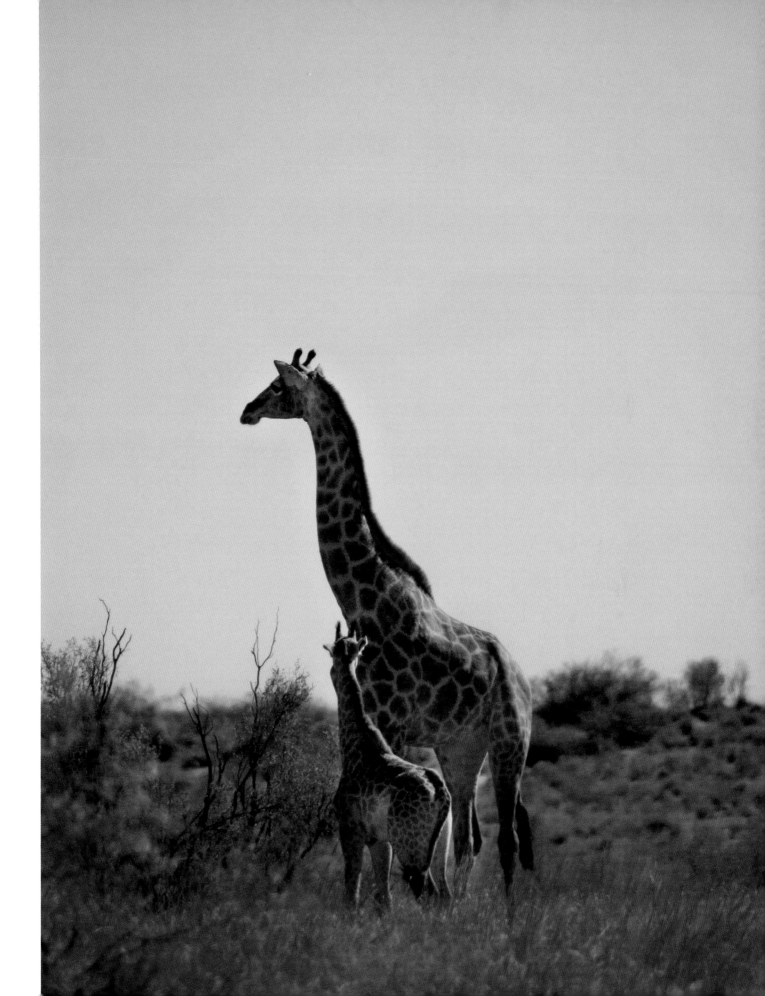

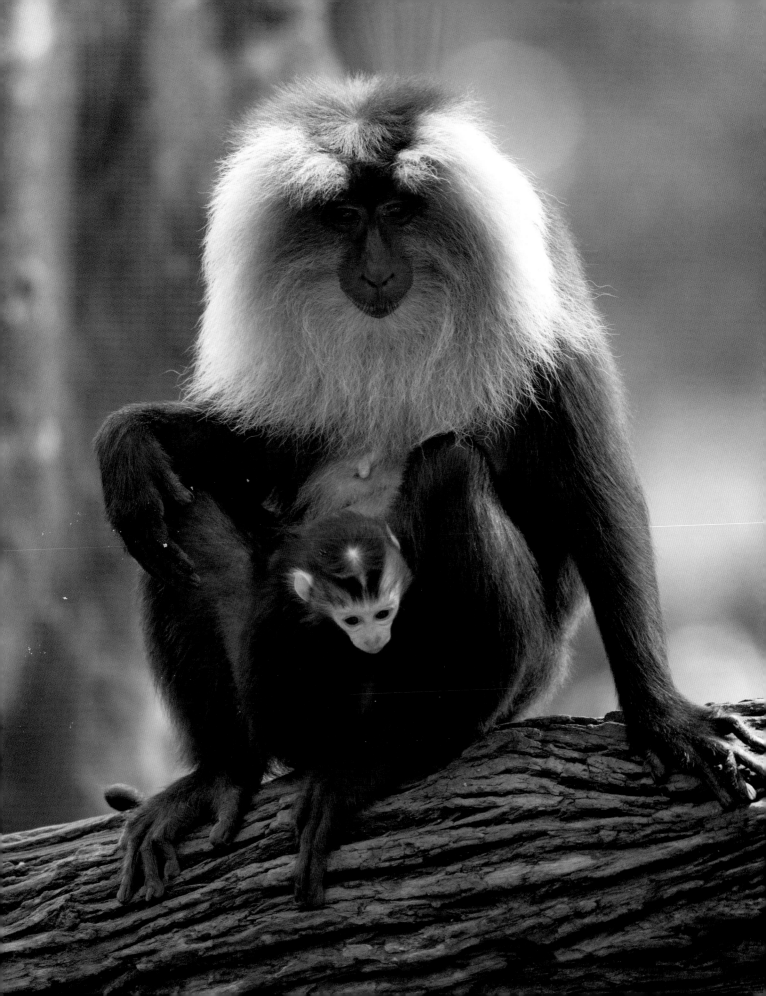

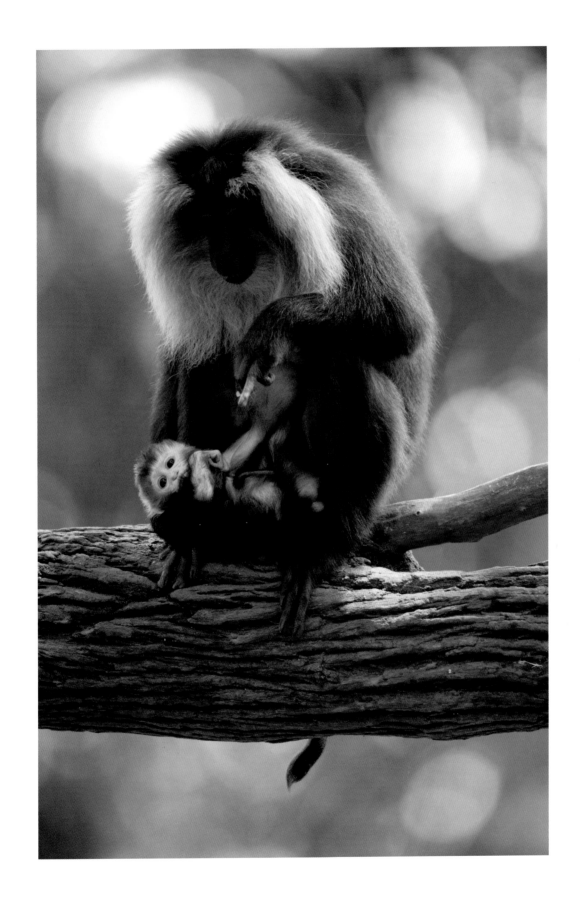

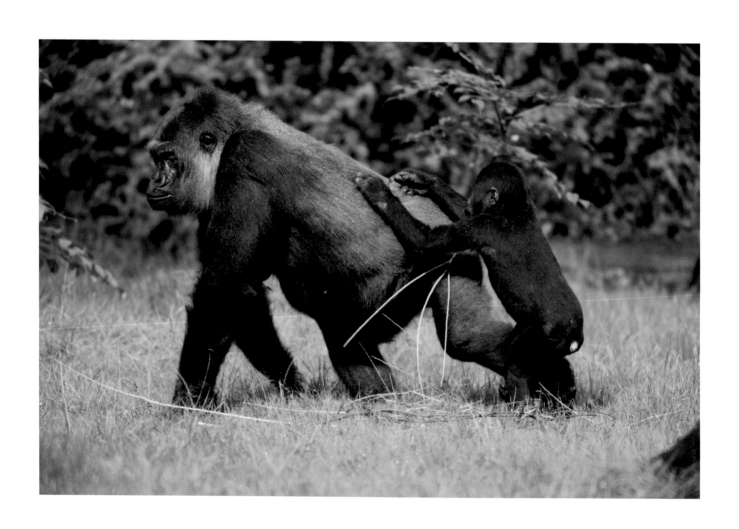

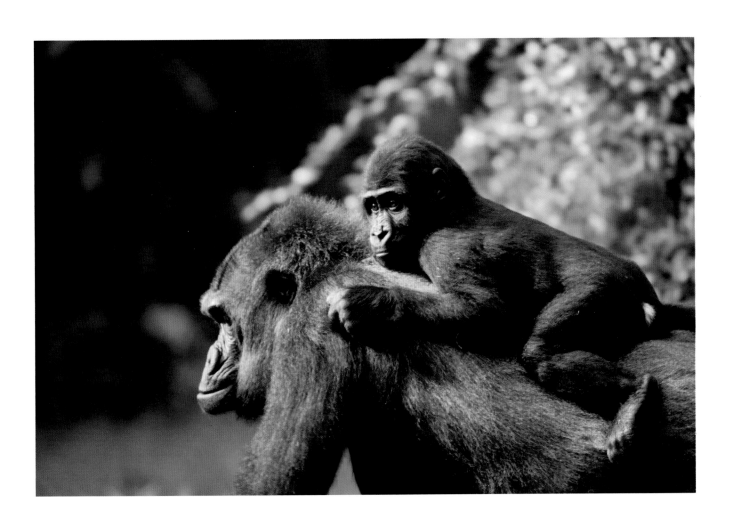

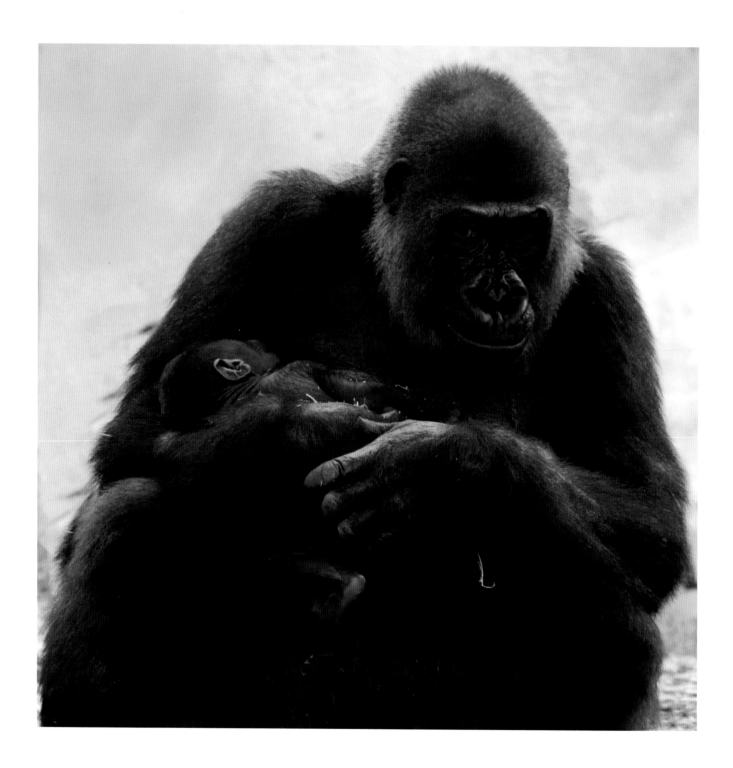

Previous spread, left to right: A western lowland gorilla *(Gorilla gorilla)* and baby at play; a mother gives a ride to her baby. *At left:* A mother gorilla cradles her baby lovingly, in human fashion.

Native to equatorial Africa from Cameroon to the Congo, western lowland gorillas are robust and powerful, with thick chests and protruding abdomens. Their faces have large nostrils and prominent brow ridges. Grown-up gorillas have long, muscular arms that are 15–20% longer than their legs, and males grow a saddle of silver gray hairs on their backs—hence the name given to them: silverback.

They live in stable family groups of 6–30, and are led by 1 or 2 silverback males. Females usually join from outside the group, and children are fathered by the silverbacks. Females mature at around 10 years, and gestation is almost 9 months. In the span of a lifetime they have up to 3 babies, which at birth weigh 3–4 lbs.

Young adult males are known as blackbacks. Gorillas usually walk about on all fours, using the knuckles of their hands (like their closest relative, the chimpanzee).

Their diet is vegetarian, and at dusk gorillas build their own crude nest for sleeping by bending branches and foliage into a bed. A new nest is built every night.

Following spread: Crested macaque *(Macaca nigra)* tending its baby in the morning light.

This black arboreal Indonesian monkey is so called because of the narrow crest of hair that runs over the top of its head from its heavy, overhanging brow.

Active during the day and primarily arboreal, the species feeds on insects, crabs, fruit, and small animals like lizards and mice.

Though sometimes incorrectly called an ape, the crested macaque is in fact a monkey. They live in troops numbering about 20, and breeding occurs at any time of year.

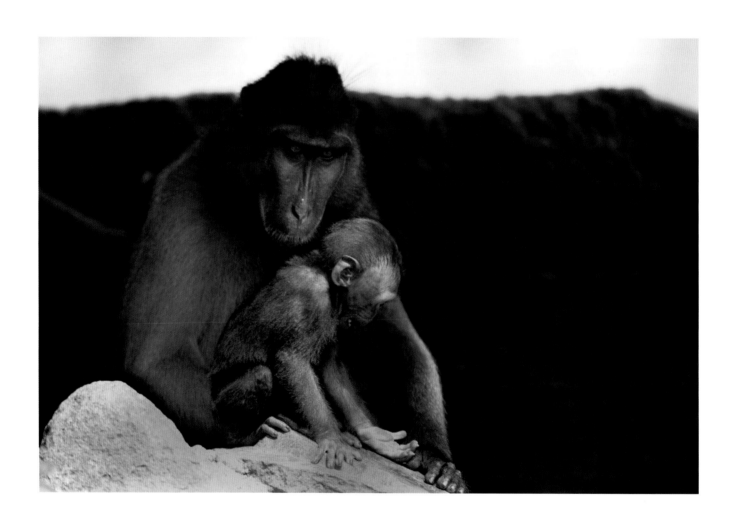

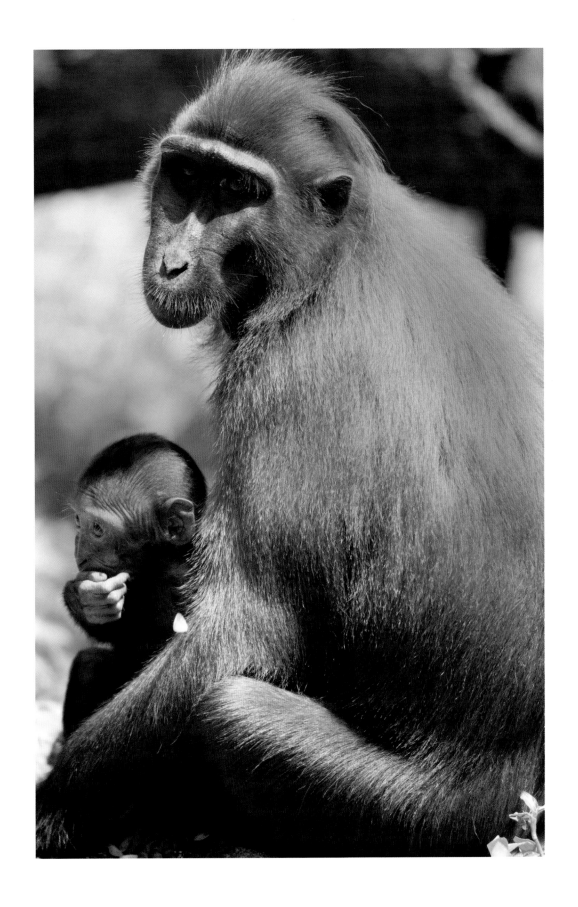

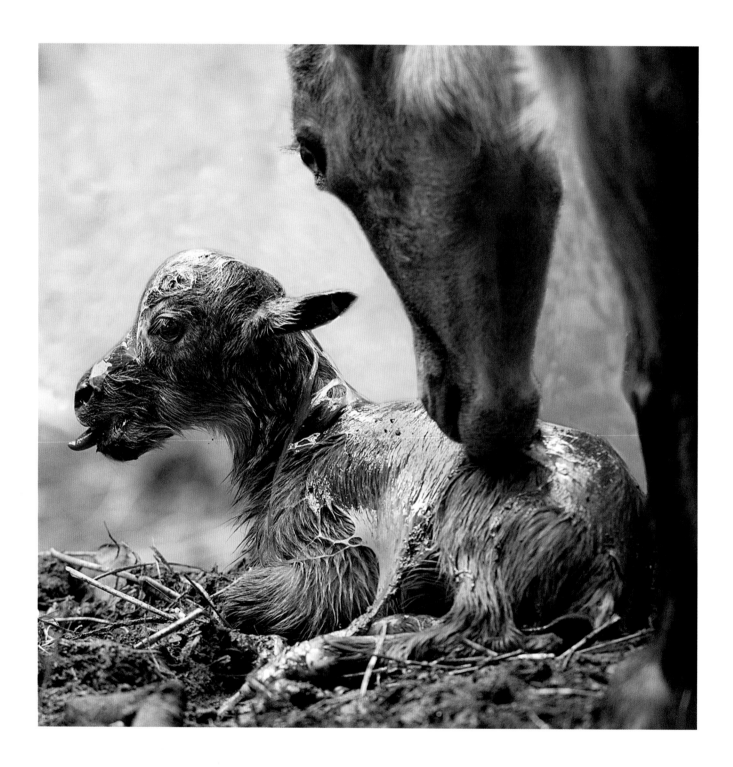

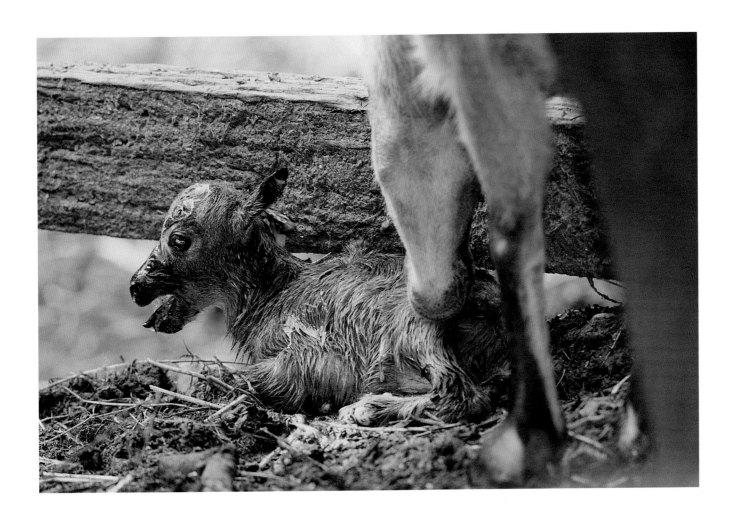

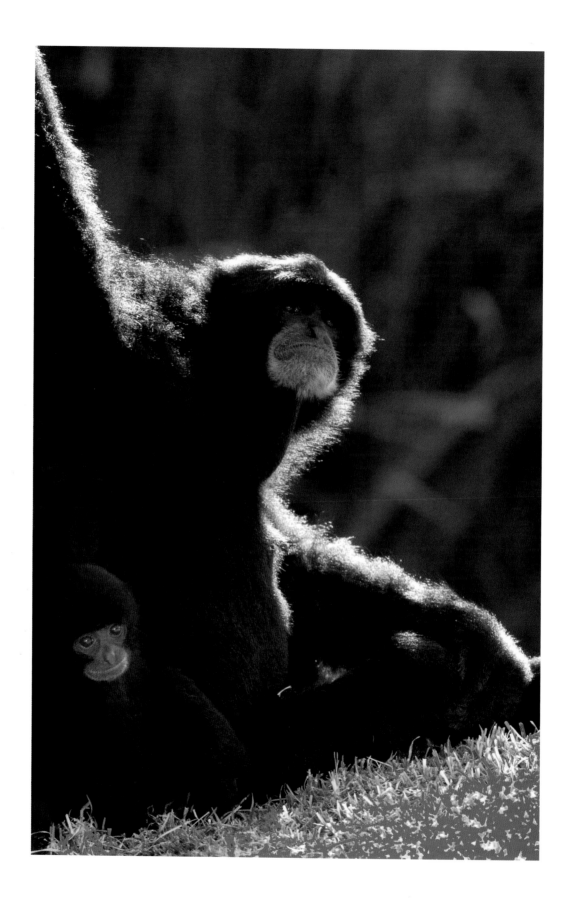

Previous spread: A Himalayan tahr *(Hemitragus jemlahicus)* carefully cleans off her tiny, newly born calf.

We watched this birth with fascination. It happened right before our eyes—the mother tahr was alone and moving across bracken when it abruptly stopped and gave birth. It was over in a matter of minutes, and the mother immediately began to clean her new child in a systematic manner. We admired that gentle mother tahr for her resilience and adaptability.

The mother tahr carries the baby for around seven months before birth, and the baby tahr will feed from the mother for six months before it is weaned onto solid food.

Himalayan tahrs are goat-like mammals found from Kashmir to Sikkim along the exacting Himalaya Mountains. Their hooves are well adapted for the steep, uneven terrain, having a hard rim of keratin surrounding a softer convex spongy pad that allows them to climb and to grip on rough ground. Males can weigh up to 300 lbs, and females, on average, are less than half that size.

At left: A siamang *(Symphalangus syndactylus)* sits with its baby on the grass. The baby gives the appearance of a quaint stuffed toy, but this was one of the rare moments it remained still.

The diurnal siamang, found in Sumatra and Malaya, is arboreal and is the largest of the gibbon family. It is the most robust as well, and has a dilatable, hairless air sac in its throat that is responsible for producing a loud booming call. Its shaggy fur is completely black, and it moves smoothly through the trees, swinging from its arms.

They carry their babies for close to 8 months, and usually only a single baby is born.

At right: A pretty-faced wallaby *(Macropus sp.)* rests with a joey in the pouch, in a reserve on the Southern Highlands of New South Wales, Australia.

The habitat for the wallaby, a middle-sized marsupial belonging to the kangaroo family, has shrunk over time. They are native to New Guinea, the Bismarck Archipelago, and Australia. The wallaby is an agile species, displaying long tails for balance and flat feet to enable it to jump large distances. It is difficult to distinguish a small kangaroo from a wallaby, but a wallaby grows not much taller than 3 feet high, and its coat is usually brighter than a kangaroo's, sometimes having reddish markings around its shoulders.

They are herbivores and feed mainly on plants and grasses. When in groups they are called a "mob." Gestation is a month, and a single baby is born that then crawls into the mother's pouch, where it remains to develop for some months before being able to fend for itself.

Following spread: A comb-crested jacana *(Irediparra gallinacea)* leads two chicks through marshy land south of Brisbane, Queensland, Australia.

This highly distinctive water bird, with its black cap and large red fleshy comb on its forehead, is less than a foot high, with long legs and exceptionally long feet that allow it to walk on floating vegetation. It feeds mainly on aquatic insects.

The female may mate with several males, yet one of them will build the nest and incubate the eggs and continue to care for the chicks. The young are precocial, and will dive and stay submerged with only their nostrils showing if they are threatened.

The nest is a shallow cup of vegetable matter, but sometimes merely a large leaf is used.

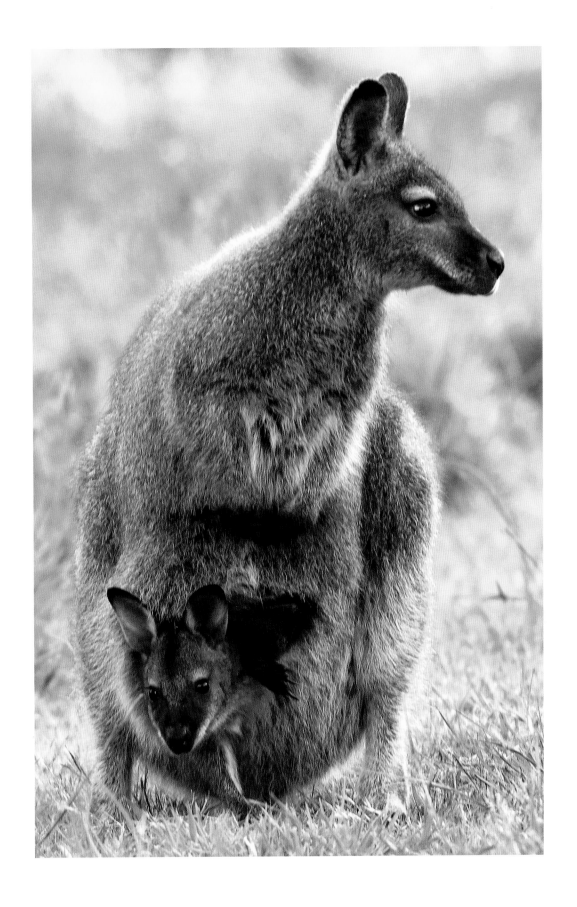

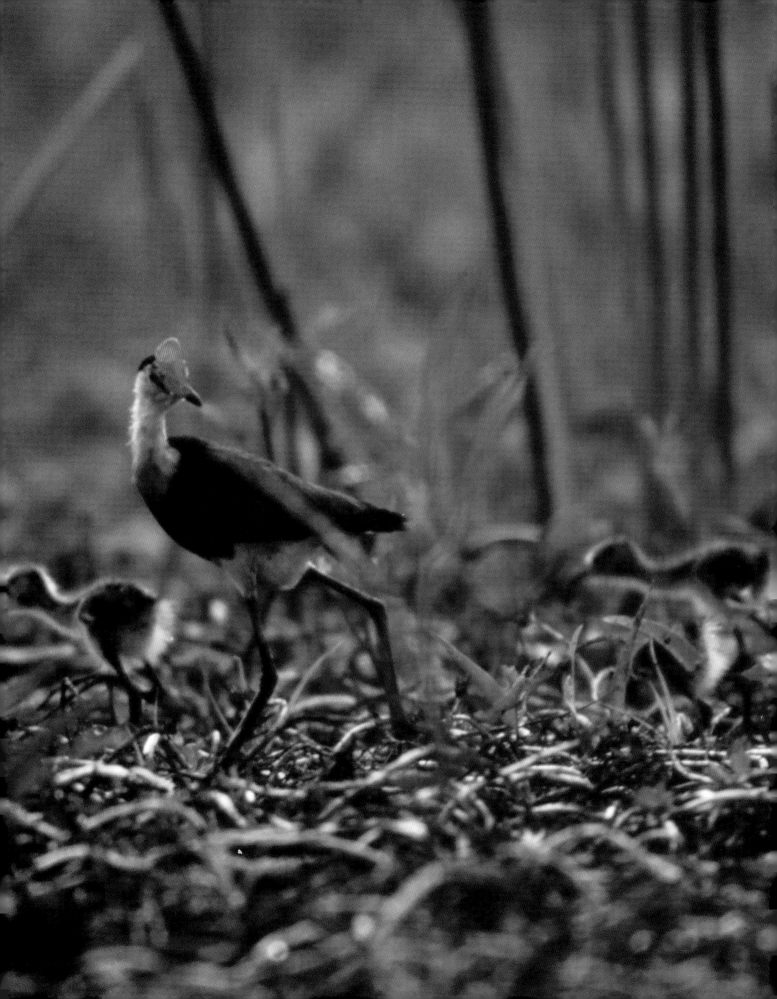

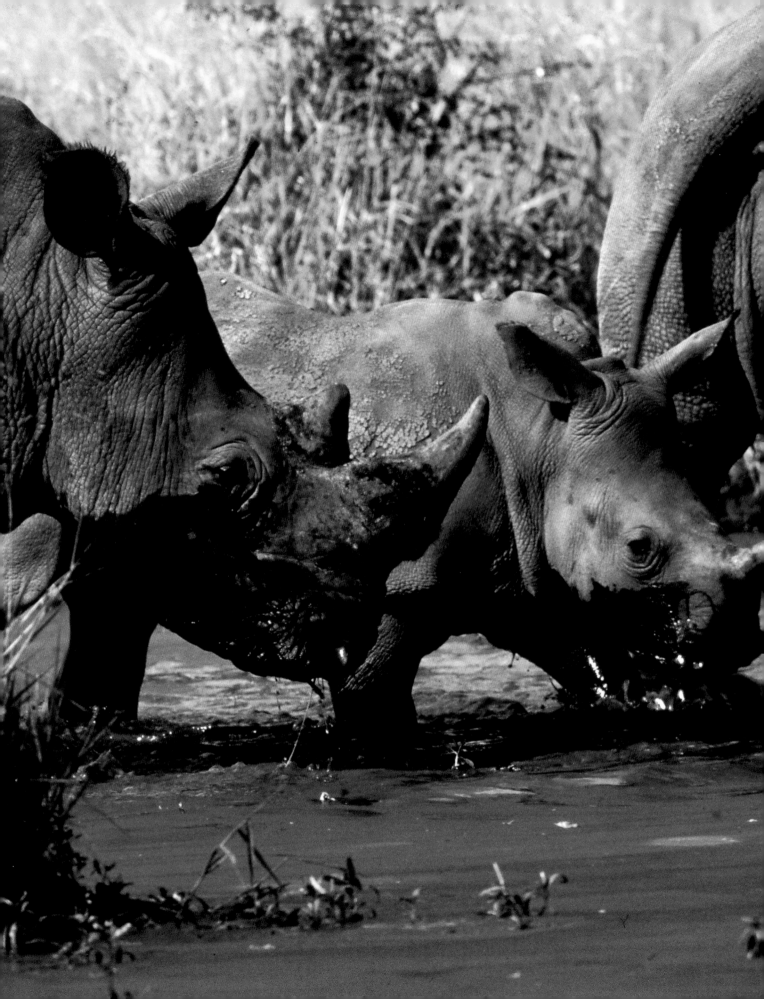

At left and following spread: A white rhinoceros *(Cerathot-herium simum)* drinks, shows affection, and rests with her baby on the veldt in Northern South Africa, near the border with Botswana. As seen here, the closest relationship a rhinoceros has is with her offspring. This lasts from 2–4 years, before the calf matures and leaves its mother.

The primitive-looking white rhinoceros is so named from the word "weit," which means "wide" in Afrikaans, and refers to the animal's broad, square muzzle. In English it is transformed to "white." It is also known as the square-lipped rhinoceros. It is one of the two species found in Africa, the other being the black rhinoceros. It can grow to be 13 feet long and 7 feet high and weigh well over a ton—sometimes as much as 3,500 lbs. It is a grazing species, and prefers to feed in short grass.

They are often seen with oxpecker birds on their backs. This bird is a good friend, eating the ticks it finds on the rhino's hide, and even warning it of anything approaching.

White rhinoceroses are the second-largest land mammal after the elephant, and have no animal predators, though there were as few as 100 survivors in 1900, mainly from hunting. Today there are perhaps 17,000, so theirs is an excellent success story.

Grown males defend territories of roughly one square mile, which they mark with energetically scraped piles of dung. The home range for females can be up to seven square miles. Breeding occurs throughout the year after a short courtship of a few weeks, and the female carries the baby for about 16 months before a single calf is born.

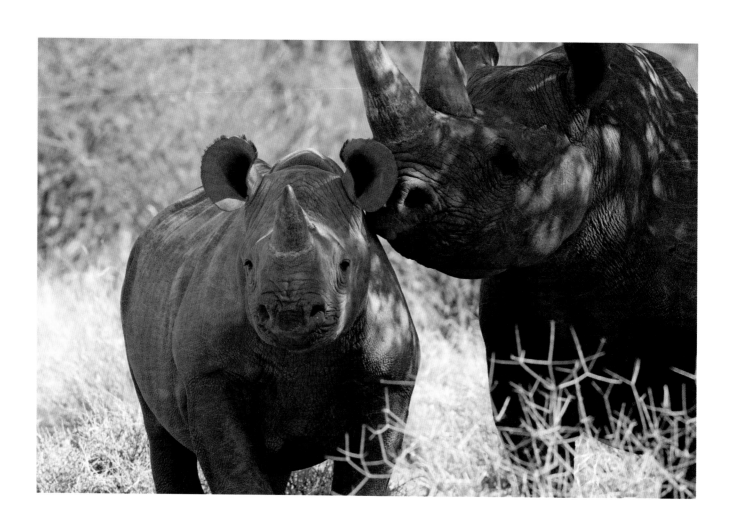

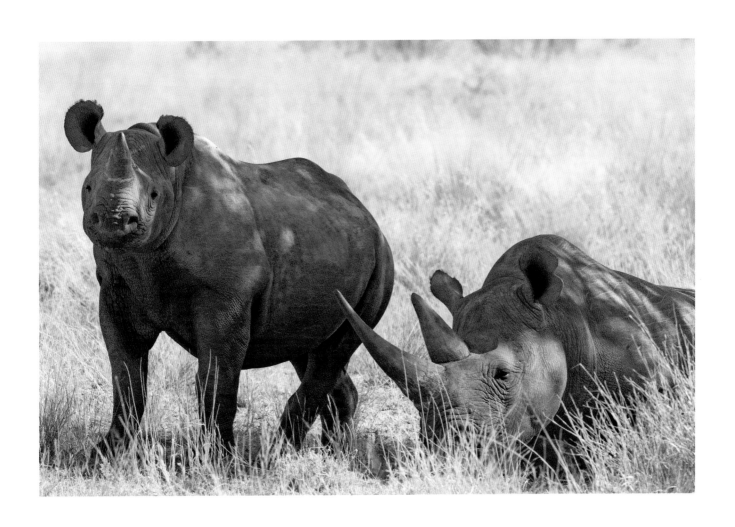

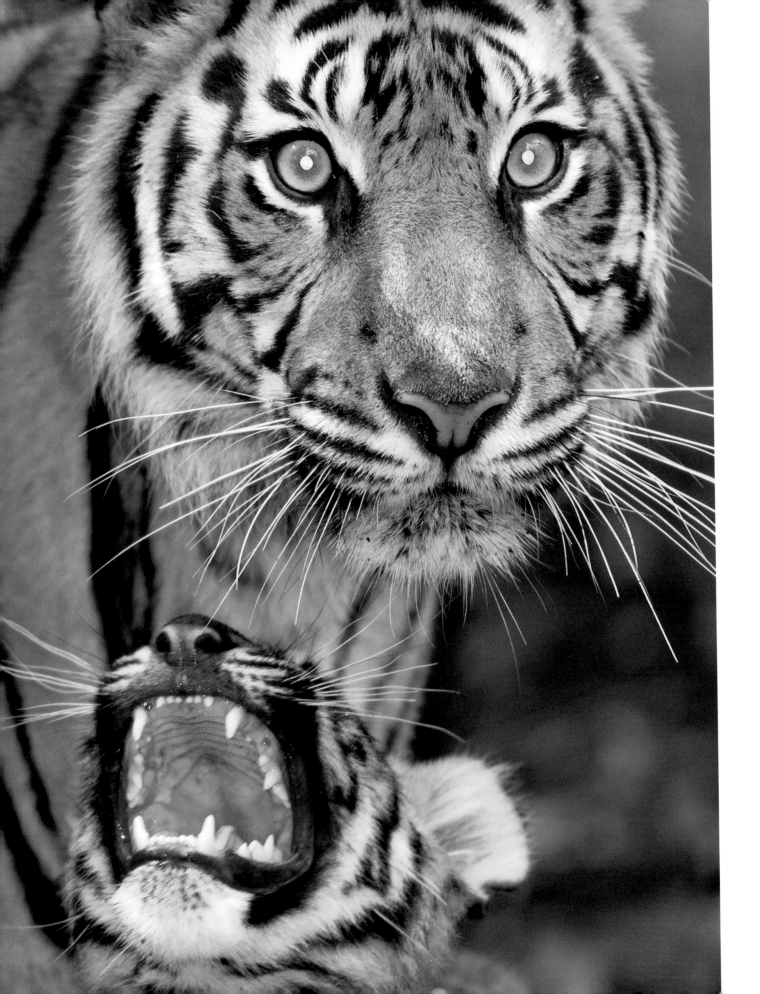

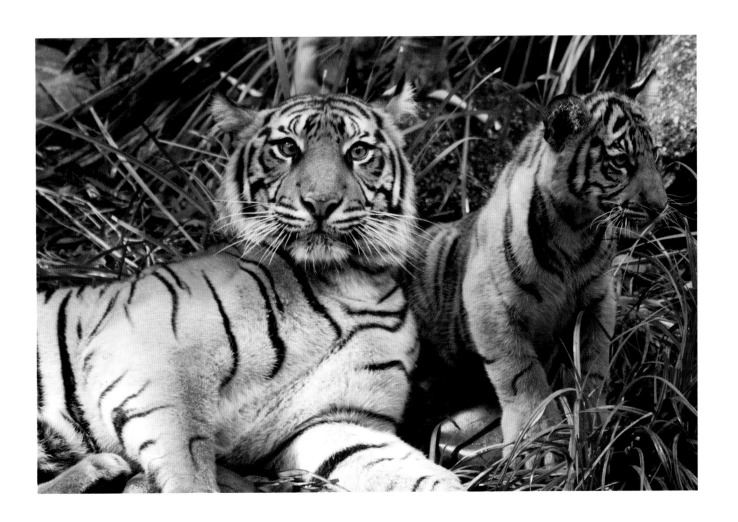

Previous spread: Mother tiger *(Panthera tigris)* watches me closely while its cub yawns, before they rest in the grass.

The largest member of the cat family, equalled only by the lion for ferocity and power, the tiger ranges from far eastern Russia, south through parts of China, India, and South East Asia. The Siberian tiger can grow to 13 feet in length.

Typically lone hunters, they stalk prey. Usually a female will give birth to 2-3 cubs every two and a half years. In the wild they can live to be 25 years old.

At right: The gentle nyala mother *(Tragelaphus angasii)* came in from the wilds of the Kalahari to birth in the protection of the camp. Her newly born calf is just a few hours old.

The females, or "ewes," and the young of both sexes of this attractive, slender antelope display chestnut-colored coats with white stripes on their torsos and above their dark noses that appear to be painted. The fully grown male, or "ram," is completely different, with its long horns twisting up and back. The ram's hair is charcoal gray, with paler stripes, and a fringe that runs under his body from throat to hindquarters. The erectile spinal crest completes this intriguing appearance.

They eat fruit, nuts, flowers, and leaves, and inhabit woodlands where there is water, but because of translocation they can also be found in drier parts of Africa. Breeding throughout the year, a single calf is born after about 7 months. Mating opportunities for rams come about from dominance behavior.

Following spread, left to right: Bison *(Bison bison)* and calf grazing; kiskadee *(Pitangus sulphuratus)* and new born chick, Bermuda; a tiger *(Panthera tigris)* with her cub mirrored in a still pool; young African elephants *(Loxodonta africana)* feed with mother in the Okavango Delta, Botswana; an orangutan *(Pongo sp.)* piggy-back ride; a mother and offspring polar bear *(Ursus maritimus)* snuggles with mother in Manitoba, Canada; capybara *(Hydrochoerus hydrochaeris)* and baby; seagull *(Larus dominicanus)* and juvenile, New Zealand; nesting frigate *(Fregata magnificens)* and baby chick, Anguilla, Caribbean; bonobo *(Pan paniscus)* and her child, so human in pose; African buffalo *(Syncerus caffer)* and calf, South Africa; and Crabeating macaque *(Macaca fascicularis)* mother and child taste leaves.

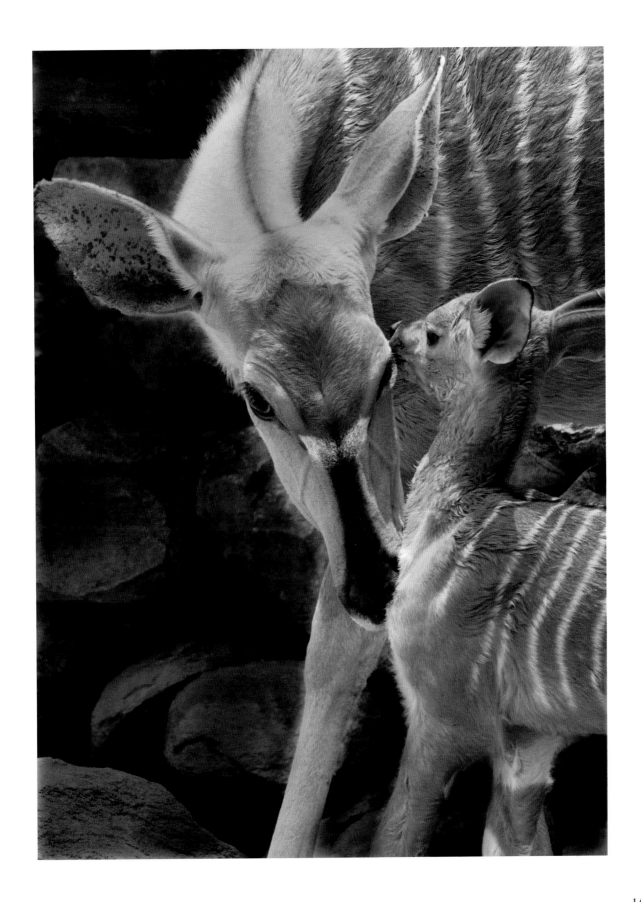

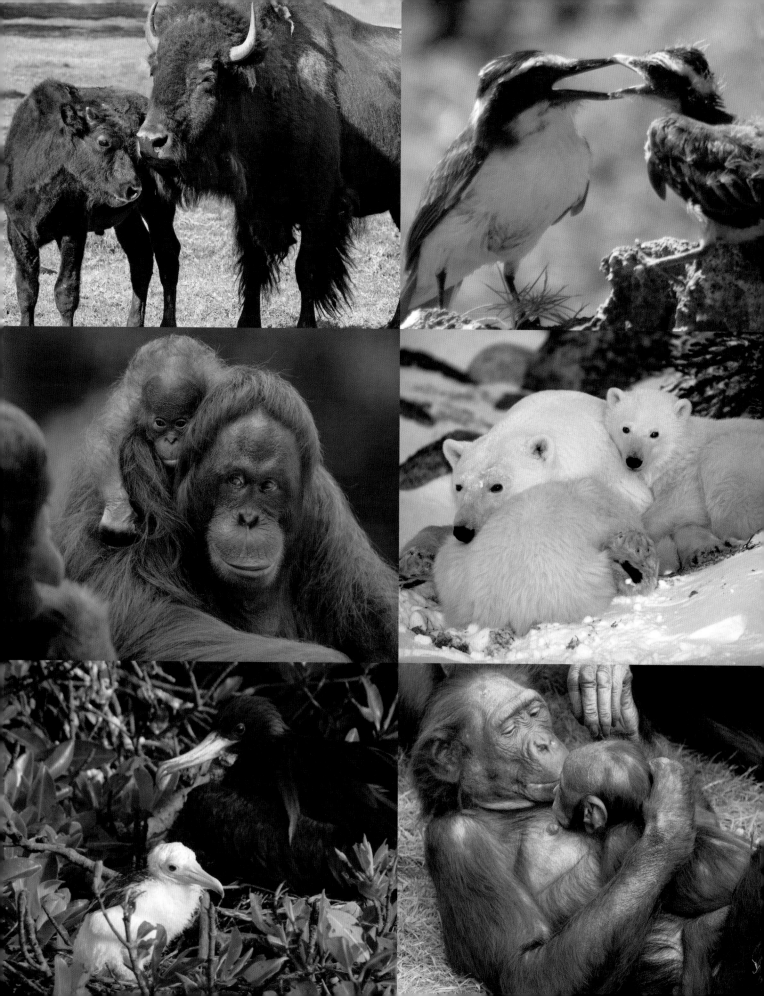

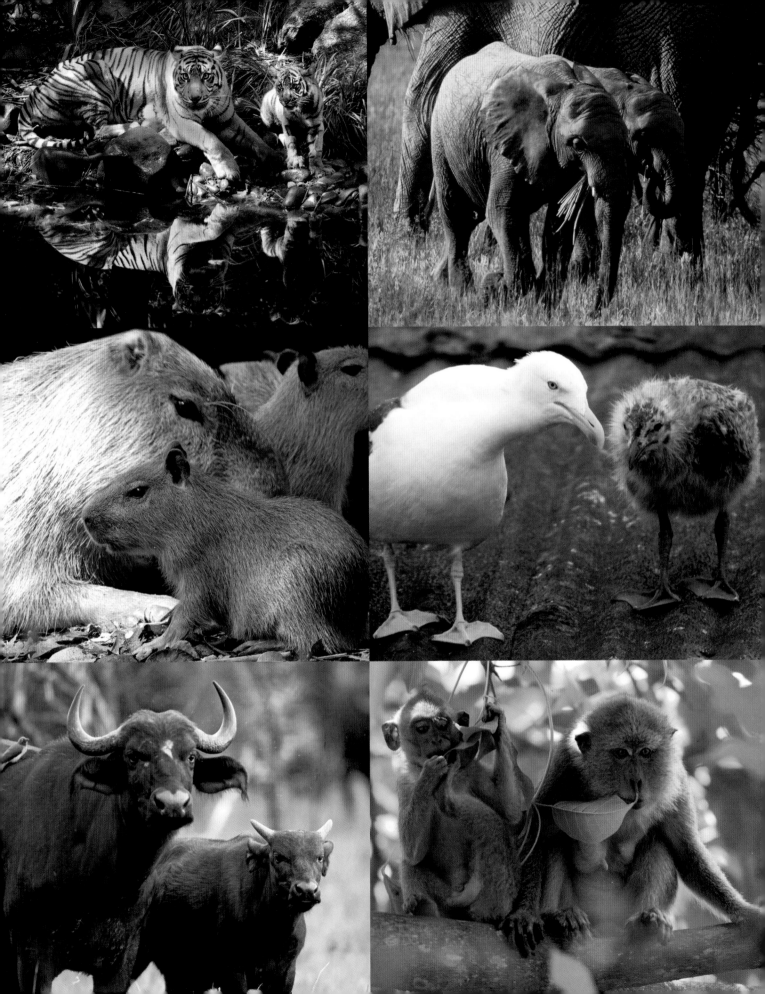

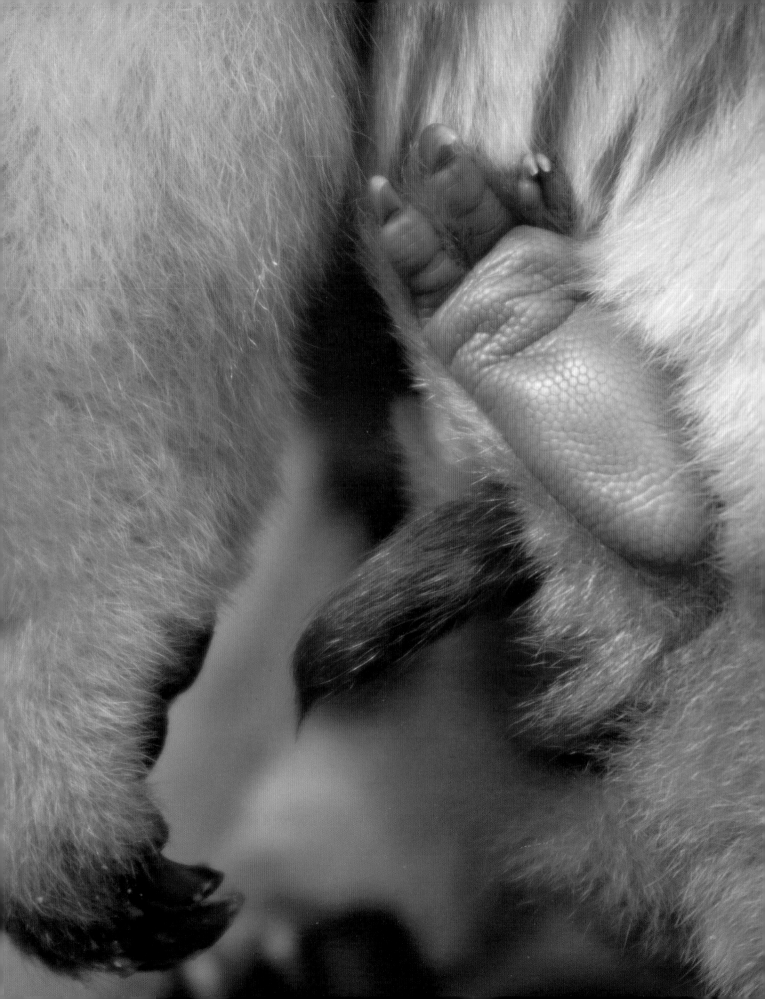

Epilogue

For over 20 years, I have regularly left my writing of books and the day-to-day business of our world to accompany my husband, Reg, into the wilds of many lands. During that time, I have been privileged to learn, tacitly, a great deal about the splendid creatures of this planet, and I have felt honored to be able to watch with fascination these resilient animals in their daily fight to survive.

I have smiled to witness the renewal of life and the vitality, quaintness, and innocence of the babies of hundreds of different species. My curiosity has been heightened to see the specific manner in which the older and more experienced teach the young and callow in the wild. I have also felt anxiety and sadness, even anger and indignation, when a handsome and elegant animal has been attacked and brought down to die in agony in order to feed the more powerful or ferocious. The "food-chain" has never sat well with me. Yet you must leave that particular, philosophical conjecture behind when you set forth, as we have done on countless occasions, to view and capture on Reg's still camera, and on my video camera, the daily lives of those inhabitants of the veldt, tundra, desert, jungle, mountains, sea, and air.

This book of Reg's is an extraordinary and touching salute to the hardy animal mothers and the offspring they nurture. A mother's role is spontaneous, whether she be human or animal. There is an innate understanding of the duty to protect, defend, and feed her young.

In the Kalahari Desert, a nyala antelope came into camp to give birth to its baby. The baby stood unsteadily very quickly after being born as the mother cleaned it with her tongue. Antelope are vulnerable, so the ability to stand and move speedily is paramount to survival in the wild. The mother nyala had instinctively realized that the camp meant a safe birth for its baby. We, of course, recording the event, were all delighted with the choice.

This inherent intimacy between a mother and its child is endlessly engaging; the essential imparting of life from the mother to the baby is astonishing. Even the stolid, seemingly characterless rhinoceros seems tender when it halts on the veldt and nuzzles the comparatively diminutive baby at its side. On our own property, on the rugged edge of a harbor in Bermuda, we have witnessed the bright yellow kiskadee parents (a rare incidence of both sexes caring for the young) remain on the ground overnight to defend and feed their fledgling that has fallen there in its first attempt at flight. Feral cats roam after dark, and the kiskadee baby can be on the ground for as long as 48 hours before it flies, so it is a fundamental part of their behavior for the parents to guard it.

The big cats—lioness, jaguar, cheetah, and leopardess—are more dangerous and more ferocious if separated from their cubs. Pity the poor photographer who accidentally comes between them.

In the lagoons on the Pacific Coast of Baja, Mexico, we have leaned out of tin boats undulating in the sea and stroked the baby gray whale that its 40-ton mother brought over, as if for inspection, to show off to us. The whale's skin felt like springy velvet, and the mother and baby remained with the boat for as long as one continued to stroke them—a magical experience.

People often ask Reg and me what our favorite animal is, and it is always difficult to answer, for they are each unique and forever appealing. Yet perhaps for me it is the long-armed, soulful-eyed orangutan, an Asian native and a gentle species for a great ape. The males seem aloof, but I like the way they all appear to be polite to one another, and the baby is, of course, so human-like. They are mainly herbivores, which appeals to me too. In contrast, I am very fond of a carnivore—the Cape hunting dog, the wild painted dog of Africa. In essence, I probably regard them as dogs, and so think kindly of them, for the little ones look so puppy-like. I know I am impressed by their hardiness and the way they endure as they run across thousands of miles in search of food and survival. While they are in danger of extinction, they are intelligent and have the ability to work together and hunt as a pack. The mother usually has a litter of 5 to 10, but only 1 or 2 live to adulthood. The babies

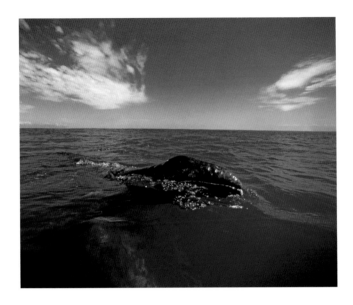

Above, left to right: baby gray whale *(Eschrichtius robustus),* with mother beneath, swimming boat-side in Scammon's Lagoon, Mexico; A pack of the endangered Cape Hunting Dogs, Kruger Park South Africa; Previous page: In this photograph, a baby Tree-kangaroo's *(Dendrolagus goodfellowi)* foot protrudes from its mother's pouch. The "joey" remains in its mother's pouch for 8–10 months. The mother cleans her pouch and groom the infant often during this phase.

look like beautiful, colorful little domestic pups, with long legs for travelling great distances, their relatively huge ears swivelling in the direction of any noise. I always have a strong desire to swoop up 3 or 4 of the babies and take them home with us to raise.

Reg and I have been fortunate enough to travel the world to capture the remarkable pictures that appear within the pages of this book. Reg Grundy, the photographer, is capable and accomplished; Reg Grundy, the television producer and original pioneer of local production worldwide, is iconic and admired. Yet Reg Grundy, the man, is so much more, and some of that is seen in the style and honesty of his images in this mother and child book. I am proud of my husband on many levels: for his integrity and his optimism; for his sheer capacity for hard work; for his dogged philosophy of never giving in, even when the odds appear unfavorable; but most of all for his humility, for his every-day normality, and for his complete lack of arrogance. He is balanced and rational and does not take himself seriously. When our dear friend and supporter Douglas Kirkland first told Reg he was a fine photographer,

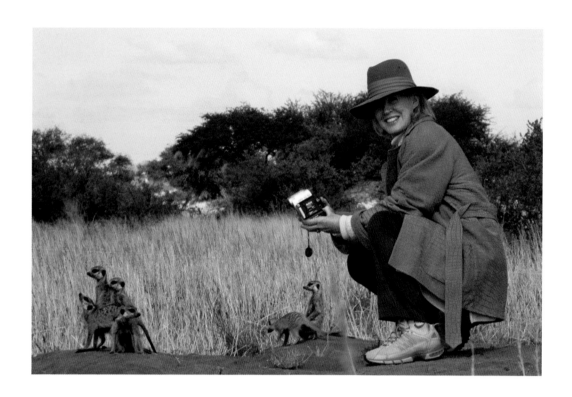

Above: Joy Grundy photographing a family of meerkats in South Africa.

Reg found it hard to believe, even though his excitement from Douglas's acknowledgement was obvious. When this consummate photographer welcomed Reg into the ranks of the photographic few, Reg did not boast, he simply worked harder at being an even more skillful creator of beautiful images. I know Reg Grundy better than any human being; I have been with him since I was a teenager, and we have shared a brilliant marriage of many decades. He does not seek notoriety and is a very private man, yet the essence of Reg appears in the pages of this book. His mother and baby pictures have all the discernment, sincerity, emotional identity, and truth of the man himself.

Those of us who accompany Reg on safari enjoy ourselves; we have mirth as a companion—in fact, laughter is one of the main characteristics of a "Grundy safari." While the picture-taking is proficient and skilled, the atmosphere is light-hearted. Reg asks a dozen times a day, "Are we having fun yet?" and his one-liners keep us amused. The happiness is infectious. We are all fellow travellers on the photographic field trips we take. At the end of a long day, when the golden light is slipping away, Reg tells us he wants

to take "just one more good shot," and we all smile skeptically at one another, because we know we'll be remaining until it is ebony dark. However, it is this relentlessness that has resulted in the photographs you have enjoyed in this book.

We have waited what seemed like endless hours for the right shot. Watching interminably for leopards to come down out of trees or for sun-basking sea lions to enter the water, or a polar bear mum and cubs to move off across the tundra; even in Bermuda, in our tranquil lagoon, we have kept guard days on end for a longtail fledgling to leave its nest in the cliff—all in the effort of producing satisfactory images. Once we were in Kruger National Park photographing a lioness that chased a warthog (another of my favorites) into its den. The lioness moved away from the hole and sat waiting, obviously hoping that the warthog would believe she had gone and thus come up out of its burrow. Hours passed while we all waited. The lioness gave up before Reg did.

For decades my husband has carried a camera with him as if it were an extension of his hand—on the table at mealtime, even in restaurants; on his seat in the car and beside him in the aircraft. In all, he has taken multiple millions of photographs, and we currently have a library of around 350,000. His finger hits the shutter night and day, and his loyal staff—Grahame, Andrew, Neil, or Chinni—have often taken hours to download and view them at the end of the day. When digital cameras arrived it became so much easier than years ago, when we had to wait until we had finally landed in London after a safari to develop the film and see the images. Ah, the relief in those days, when at last we saw good, sharp photographs.

While my husband's vocation was television production, and he devoted a life-time to it, his avocation has been making magical still images, in getting the right shot. Even before his love affair with the camera, he used to see pictures all around and would constantly call my attention to things that intrigued him. "Joy, look at that." "Joy, look at this." Reg was a natural to take up photography in earnest.

— Joy Chambers-Grundy
Bermuda

Biographies

Dr. Reg Grundy AC OBE is known around the world as a television icon. He has been named one of "The 50 Most Influential Australians of All Time" and produced more than 160 different television programs. In 1959 he established his first television production company, Reg Grundy Enterprises, in Sydney, Australia, and in the late 1970s he created Grundy Worldwide, which became the largest independent television production and distribution company in the world. He was the original pioneer of local television production on an international scale and operated offices in more than 20 countries during the 1980s and 1990s. His television programs were distributed in over 76 countries.

Yet his delight and avocation have remained wildlife photography. Grundy has traveled all over the globe to capture his images, and his exhibitions have appeared in New York and Los Angeles, in most capital cities of Australia, and in Bermuda, where exhibitions remain indefinitely at the Wade International Airport and the National Museum. This is his third book, his first two being *The Wildlife of Reg Grundy* (2005) and *Bermuda Longtail* (2011), both published by Longtail Press.

He lives with his wife, the historical fiction author Joy Chambers, in Bermuda, their home of 30 years, which they share with their Shetland Sheepdogs.

www.rgwildlife.com

Joy Chambers-Grundy is an historical fiction author, company chairman, and a business woman, who began her career as a television actor in Australia, where she won awards for her performances. She appeared in the international hit *Neighbours,* which, at its height, was seen in 76 countries. Joy has written six widely-read, fact-based, fiction books, the most recent being *The Great Deception* (2013). Joy is married to Reg Grundy and accompanies him around the world on all his photographic safaris and expeditions.

Douglas Kirkland is one of the best-known photographers of our time and has worked for *LOOK* and *Life* magazines, where he photographed such icons as Elizabeth Taylor, Marilyn Monroe, and Marlene Dietrich. He has worked on the sets of over 150 motion pictures. His numerous awards include: a Lucie for Outstanding Achievement in Entertainment Photography and a Lifetime Achievement Award from CAPIC in Canada. In February 2011, the American Society of Cinematographers presented him with the prestigious President's Award.

Guy Cooper PSM is an international business executive and respected leader in environmental education and conservation, most recently in his role as Director and Chief Executive of Taronga Conservation Society Australia (TCSA). He established globally-recognized conservation programs for endangered fauna including the Tasmanian devil, black rhino, and Asian elephant. He lives in Sydney, Australia with his wife, Jeanette.

Index

At right: In a tiny cavern in the cliffs of our home in Bermuda, waiting for his mother (or father) to return with food, sits a baby longtail, the white-tailed tropic bird *(Phaethon Lepturus Catesbyi)*, my favorite bird.

We named this little fellow Longford and watched him grow and mature until I photographed him when he fledged and flew away. At this age, he carries black-barred feathers, and his eyes are prominent in the fluff around his head.

Longtails are sea birds, only coming to land to breed. They mate for life and return to the same nesting hole each year.

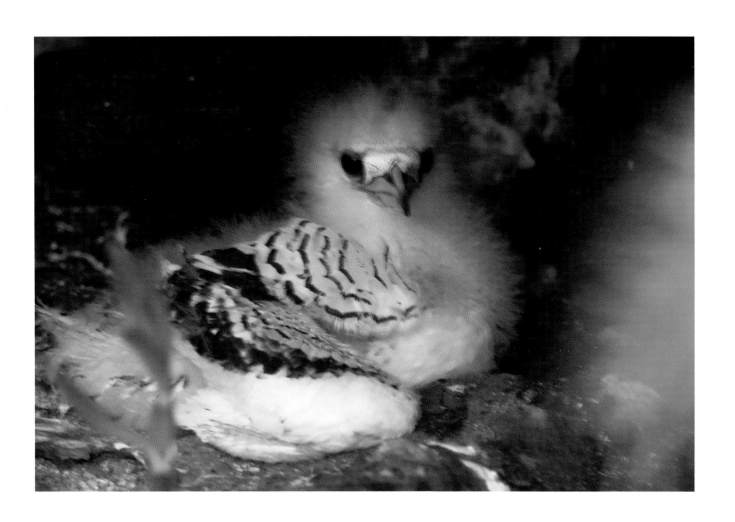

Acknowledgments

This book has seen the light of day with the expertise and exceptional skill of Marta Hallett, keen-eyed founder and publisher of Glitterati, and her team, in particular Sarah Morgan Karp, her very imaginative art director. To them I pay tribute, along with my dear friends the uniquely skilled and world-renowned photographer Douglas Kirkland, who, though younger than I, was my mentor, and his gifted wife, the enchanting Françoise, whose grace continues to brighten our days. This collection of images would not have materialized without them.

My deep appreciation extends to another friend for his generously written foreword, the competent, professional Guy Cooper, an admirable man and Australian Father of the Year 2010, who was for 18 years the Chief Executive Officer of the internationally famous conservation resources Taronga and Western Plains Zoos. Then there is the group of first-rate, professional companions around me who continue to deliver, including my curator, Chinni Mahadevan, and Neil Freestone and Andrew Jenkins. Thanks too go to my original photographic assistant of many years, Grahame Bateman.

And forever there is my wife, Joy, my muse and my love, who partners me in my creative endeavors, my business ventures, and all that I do every day of my life.

— Reg Grundy